The College History Series

BLACK COLLEGES OF ATLANTA

RODNEY T. COHEN

On the Cover: The Atlanta University debate team, *c.*1912, includes from left to right, Asa Gordon, Domion Glass, and Loring Moore.

The College History Series

BLACK COLLEGES OF ATLANTA

RODNEY T. COHEN

Copyright © 2000 by Rodney T. Cohen.
ISBN 978-0-7385-0554-1

Published by Arcadia Publishing
Charleston, South Carolina

Printed in the United States of America

Library of Congress Catalog Card Number: 99-069523.

For all general information contact Arcadia Publishing at:
Telephone 843-853-2070
Fax 843-853-0044
E-mail: sales@arcadiapublishing.com
For customer service and orders:
Toll-Free 1-888-313-2665

Visit us on the Internet at www.arcadiapublishing.com

This work is dedicated to the ancestors, known and unknown, whose efforts made possible the black colleges of Atlanta.

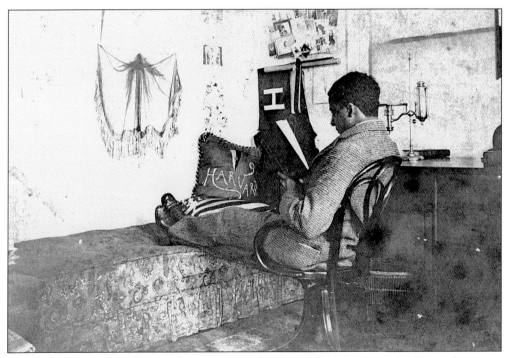

George A. Towns, a member of Atlanta University's Class of 1894, is pictured at Harvard.

Contents

Acknowledgments 6

Introduction 7

1. Campus Scenes and Landmarks 11

2. Administrators and Scholars 41

3. Alumni 51

4. Fraternities and Sororities 57

5. Campus Culture 71

6. Pomp and Circumstance 99

7. Athletics 109

8. Academic Life 121

Bibliography 128

ACKNOWLEDGMENTS

I would like to acknowledge those who made possible my sojourn, provided inspiration, served as an example, and assisted with materials. First, thanks go to my parents, Rudolph R. and Eula M. Cohen, both graduates of Clark College, for laying the foundation and background of my early exposure to higher education and, more specifically, black higher education

I would also like to acknowledge other members of my family, including my brother Rudolph R. Cohen Jr., sister-in-law Robbie Cohen, and aunt Alexandra Cohen, all graduates of Clark College. Thanks to the future Clarkite, my niece Shannon Cohen; to my aunt Pearlie Reeves, a graduate of Cheyney; to my cousin Claude Adams, a graduate of Bethune Cookman; and to my cousins Kenny Adams and Charles Myers. I would also like to acknowledge our family matriarch, my grandmother, Mrs. Susie Jones.

Additional acknowledgment goes to Herman "Skip" Mason of Morris Brown, who provided me with the inspiration and example for such a project; to Alexander D. Hamilton VI of Morris Brown, for providing valuable and rare family artifacts; and to Jeannie Douglass Taylor, a graduate of the old Atlanta University, for her stories and materials of AU. Thanks to Kassie Freeman, my academic advisor and proud graduate of historical Tuskegee Institute, for always promoting black higher education whenever possible. Also, thanks go to Meca Walker and Kedra Taylor for their continued love and support of historically black colleges and universities. To my brothers in Alpha Phi Alpha, more specifically to the Alpha alumni of Clark and the Alpha Alumni of Western Kentucky University, including Terrence Kennon, Terrence Moore, and Tim Tibbs. Acknowledgment also goes to my past and present colleagues of Notre Dame, Vanderbilt, and Western Kentucky.

I would like to extend my appreciation to my many comrades who continue to represent historically black colleges, holding high the light: Jarrod K. Grant of Wilberforce, Gerry White of Clark, Juan McGruder of Clark, Diaam Shabazz of Clark, Paul Harper of Fisk, Nikki Wright of Fisk, Bobby Hemmitt of Clark and Benedict, Glen Pontoo of Benedict, Rick Robinson of Clark, Eric Means of Clark, Clyde Gaylord of Clark, Walter Hales of Morehouse, Mark Edwards of Atlanta, and the once Jewels of Atlanta.

I would also like to acknowledge my friends and colleagues in the Office of Development at Clark Atlanta; Getchel, Sherry, Mabel, Vivian, Gloria, Toni, Chris, and Curtis; and my international friends in the UK, Patsy and Deborah.

Without the inspiration of those who came before me, none of this would have been possible. Therefore, I would like to pay tribute to the following individuals who have influenced my appreciation for history, black culture, and historically black colleges: Charles H. Wesley, Clarence Bacote, James P. Brawley, E. Franklin Frazier, Charles S. Johnson, Matthew S. Davage, Mordecai Johnson, Benjamin E. Mays, John Hope, John Henrik Clarke, John G. Jackson, St. Clair Drake, Alain Locke, Carter G. Woodson, and the great W.E.B. DuBois.

Last but not least, thanks to Katie White and Arcadia Publishing for their interest in this project.

Introduction

Education is the highest measure of a nation and a people's progress and status in society. The rise of the black college in American history is probably one of the greatest marvels of the 20th century. Never before in the history of the world has a group of people met with such overwhelming challenges and opposition to obtain an education and, more specifically, a higher education. Never before have the odds been so insurmountable, but overcome. At the close of the Civil War, practically all of black America was illiterate; however, by the end of 1910, only 30 percent were illiterate (Miller and Gay, 1917). In this spirit to continue to progress and combat the citadel of racial hegemony, black America saw the rise of a group of schools, colleges, and universities dedicated to providing education to the once servile group.

The movement to provide higher education to black America began during and after the Civil War. At the dawn of secession in the mid-1850s, black colleges such as Lincoln University in Pennsylvania and Wilberforce University in Ohio were established, thus beginning the black college movement in America (Thompson, 1973). The black colleges of America, by all intents, provided the only reliable opportunity for black youth to obtain a higher education. The aspirants of a black higher education were usually imbued with the desire to help in the movement of racial uplift. As a result, by the 1920s the rate of literacy had increased to nearly 80 percent (Thompson, 1973). Black colleges, with little or no cooperation from majority institutions, trained the hundreds of black teachers and scholars who were able to significantly reverse the rate of illiteracy in black America.

Approximately a decade after the founding of Lincoln and Wilberforce, the need to establish higher education in the Deep South was evident with the coming of Atlanta's black colleges: Atlanta, Clark, Morris Brown, Spelman, and Morehouse. By 1865, although Atlanta and the Confederacy still lay wounded in the ashes of the Union's destruction, black higher education began its thrust for recognition. The first of the Atlanta colleges to be founded for blacks was Atlanta University (AU) in 1865, followed by Morehouse College in 1867, Clark University in 1869, and Spelman and Morris Brown Colleges in 1881.

Atlanta University was the pioneer college for blacks in the state. It was incorporated in 1867, with the first normal school class graduating in 1873 and the first class of college rank graduating in 1876. During the early years of the university, emphasis was on the development of primary and secondary education, preparing students for advanced college and university work. In 1894, all pre-high school work was discontinued, and during the first two decades of the 20th century, all high school work was phased out. By the mid-1920s, the university boasted of faculty from such schools as Chicago, Oberlin, Boston, and Harvard (Klein, 1929). Because of its outstanding reputation and accreditation, many of Atlanta's graduates were admitted to the top graduate schools of recognized universities, including Harvard, Chicago, Columbia, and NYU. Atlanta University also gained recognition from the American Medical Association (AMA) as a Class A institution for the preparation of medical students (Klein, 1929).

Unlike the other schools, Morehouse College began outside of Atlanta in Augusta, Georgia. Organized in 1867 as the Augusta Institute, Morehouse was founded under the auspices of the American Baptist Home Mission Society of the Northern States (Brawley,1917). In 1879, the Augusta Institute relocated to Atlanta and was incorporated as the Atlanta Baptist Seminary. Originally housed in a three-story brick building, the school moved twice—once in 1889, and finally in 1890 to its present location in West Atlanta. In 1897, the school's charter was amended in order to make the institution of college grade, and the name was changed to Atlanta Baptist College. In 1913 the charter was once again amended, and the school became known as Morehouse College. By the 1920s, Morehouse had been rated by a number of accrediting agencies. The AMA, in 1920, rated Morehouse as a Class A institution. In 1926, the state department of education approved the work of Morehouse as standard collegiate grade. By 1921, Morehouse was the first black college in America to erect a building solely for the study of science. The Science Hall, as it was then known, was valued at $120,000 (Fuller, 1933). Morehouse was also unique in that it was the only one of the Atlanta colleges founded exclusively for the education of black men. It was one of only two black, all-male institutions in America—the other being Lincoln University in Pennsylvania.

In 1869, approximately two years after the founding of Augusta Institute (Morehouse), and not long after the last Federal troops withdrew from Atlanta, Clark University was formed. Founded by the Freedman's Aid Society of the Methodist Church, the university was named in honor of the society's president, Bishop D.W. Clark. The university spent its first two years in the downtown section of Atlanta. In 1872, Clark moved to a better location a short distance south of the corporate limits of the city of Atlanta, known as South Atlanta. The 400 acres of land purchased in South Atlanta became the permanent site of "Dear Ole" Clark until its move to West Atlanta in 1941. Adjoined to the campus of Clark University was the Gammon Theological Seminary, an institution of note for the training of black preachers and leaders. Gammon evolved from the Clark University Theological School (Brawley, 1977). By the early 1920s, Clark also experienced new developments like its sister institutions. The university was organized into a liberal arts college, with some preparatory work (which was later discontinued). The Clark faculty was made up of graduates of such institutions as Northwestern, Meharry, and Chicago.

The year 1881 saw the development of Morris Brown College. Incorporated under the control and guidance of the African Methodist Episcopal Church of Georgia, Morris Brown was the only one of the Atlanta colleges to be "founded by blacks for blacks." The college erected its first building in 1884, only three years after being founded. Six years later in 1890, Morris Brown graduated its first class. In 1906, the college was incorporated under the laws of the state as Morris Brown College. In 1913 the name was changed from Morris Brown College to Morris Brown University (Sewell and Troup, 1981). By the late 1920s, Morris Brown enrolled 186 students in college-level courses and 257 students in four-year high school courses. Morris Brown maintained a four-year college of arts and sciences and a three-year theological school known as the Turner Theological Seminary.

Also founded in 1881, Spelman College was the only college established in the state for the exclusive purpose of educating black women. Organized as Spelman Seminary, the school bore that name until 1924, when it was established as a four-year college (Klein, 1929). Chartered under the laws of Georgia in 1888, the school was named after Laura Spelman Rockefeller. A number of buildings on the Spelman campus were erected through the generous gifts of the Rockefellers. These buildings included Sisters Chapel, Rockefeller Hall, and the Laura Spelman Rockefeller Memorial Building.

By 1929, three of the five black colleges of Atlanta experienced a change in organization. Atlanta University discontinued undergraduate work and affiliated with Morehouse and Spelman in a plan known as the "Atlanta University System." According to this plan, Morehouse would be responsible for all undergraduate activity for men, while Spelman would be responsible for all undergraduate activity for women. In turn, Atlanta University would provide all programs and courses at the graduate level. In 1932, as a result of this agreement, it was necessary for Atlanta University to move to a location closer in proximity to the campuses of Spelman and Morehouse.

Morris Brown University would also relocate that year, and Clark University followed in 1941. The impetus for the affiliation of the Atlanta schools stemmed largely from the development of a central library. The formation of a combined library, which would house all of the holdings of the Atlanta colleges, proved beneficial to the academic development of these schools. This combined effort would place the Atlanta library second only to Howard University among black college holdings. Furthermore, in comparison to all other college libraries in the state (regardless of race), the Atlanta library ranked only behind that of Emory and the University of Georgia in its holdings.

Although the close physical proximity of Clark, Morris Brown, Atlanta, Spelman, and Morehouse existed as early as 1941, a formal agreement of cooperation including all of the Atlanta colleges did not occur until 1957. The controlling boards of the six institutions (including Gammon Theological Seminary) created the Atlanta University Center, ensuring that all of the institutions held membership as equals. Almost simultaneously with the formation of the Atlanta University Center, the theological departments of Morehouse and Morris Brown discussed the possibility of creating a unified institute of theology with Gammon. As a result, in 1956, Gammon, Morehouse, and Morris Brown's Turner Theological Seminary merged to form the Interdenominational Theological Seminary. They were also joined by Phillips Theological Seminary of Lane College in Jackson, Tennessee.

It has been a long road since the development of Atlanta University in a boxcar, where a small group of black children met to learn; since the humble beginnings of Augusta Institute, in a three-story building; and since the early struggles of that "school on a hill," known as Clark University, to the major campuses of the AU Center—today totaling over 10,000 undergraduate, graduate, and professional students.

In an attempt to bring to life the formation, development, and impact of Atlanta's black colleges, this collection of photos, documents, and programs has been compiled. The aim of this collection is to provide a rich visual account of one of America's great treasures—the black college. Although the story of the Atlanta University Center has not yet been told in its entirety, *The Black Colleges of Atlanta* will serve as a precursor and discussion piece for a seminal work to come on the Atlanta University Center.

Rodney T. Cohen

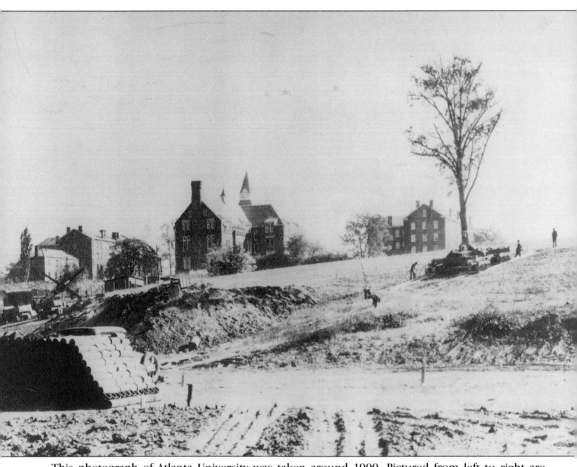

This photograph of Atlanta University was taken around 1900. Pictured from left to right are North Hall, Stone Hall, and South Hall. Atlanta University remained at this location until the late 1920s, when it relocated to a plot of land adjacent to Morehouse and Spelman Colleges.

One

CAMPUS SCENES AND LANDMARKS

South of the North, yet north of the South, lies the City of a Hundred Hills, peering out from the shadows of the past into the promise of the future. I have seen her in the morning, when the first flush of day had half-roused her; she lay gray and still on the crimson soil of Georgia.

—W.E.B. DuBois

It was not until 1949, 17 years after its construction, that the administration building of Atlanta University received its name. Called Harkness Hall, it was named after the great benefactor Edward S. Harkness. It is pictured here, c.1940.

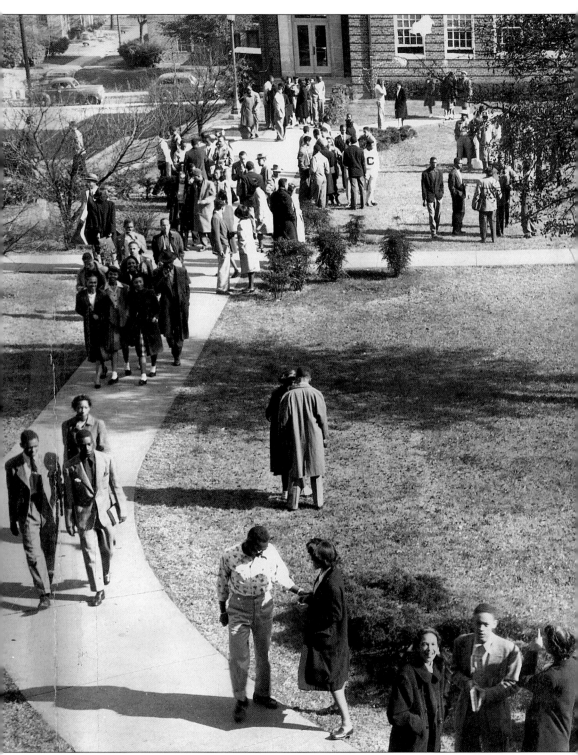

Shown on a typical school day, c.1950, are students from Clark College as they enjoy an autumn walk through the beautifully landscaped Thayer Quadrangle. The quadrangle takes its name from

12

Thayer Hall, shown in the background. James P. Brawley compared the cultural atmosphere and elegance of Thayer Hall to the Commons of Christ College at Oxford in England.

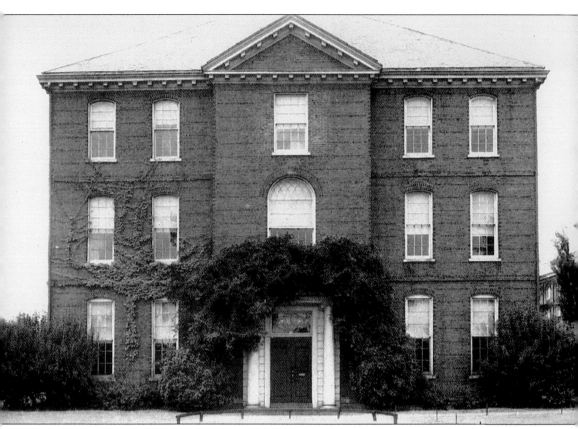

One of the most significant and progressive changes in the history of the Atlanta School of Social Work was when it affiliated with Atlanta University in 1938, thus becoming officially known as the Atlanta University School of Social Work.

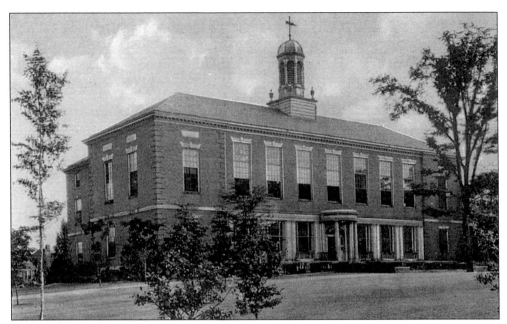

In 1929, Atlanta University, Morehouse, and Spelman were formally affiliated in a university plan to become the Atlanta University System. As a result of this affiliation, the book collections of the three institutions were brought together to form the new Atlanta University Library. Shown is the University Library, c.1935, which was made possible by a gift from the General Education Board.

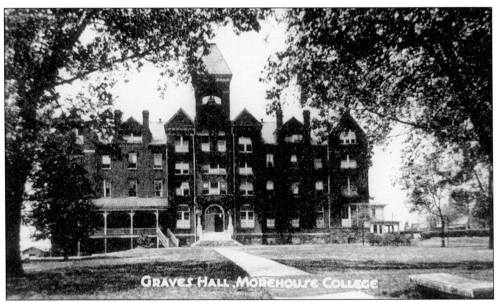

For years Graves Hall has served as the cultural, moral, and intellectual hub of Morehouse College. Named after President Samuel Graves, the structure was erected in 1889 on a historic plot of land. This land was marked by the Confederate Army, which offered stubborn resistance to the Union forces during the siege on Atlanta (Brawley, 1917).

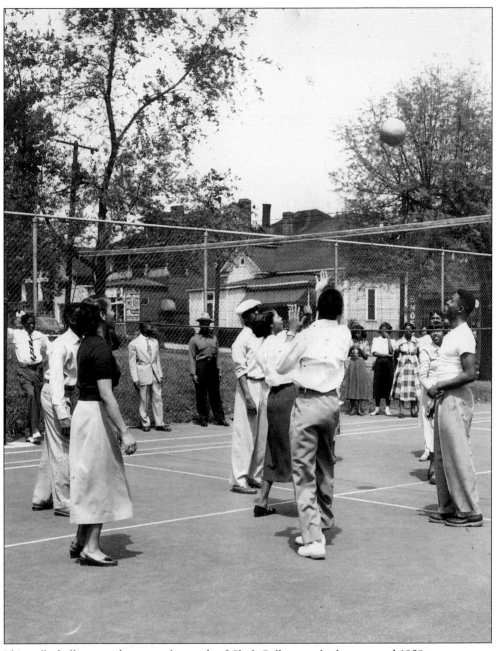
This volleyball contest between the coeds of Clark College took place around 1950.

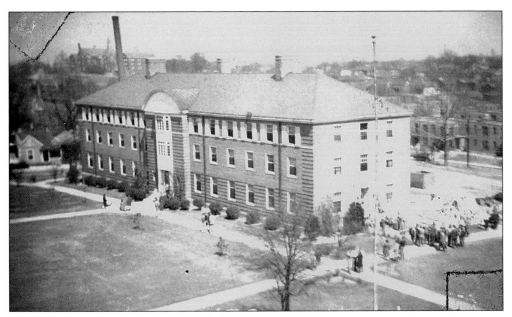

During the first eight years following Clark's relocation in 1941, there were only two dormitories on this new site, Merner and Pfeiffer Halls (Brawley, 1977). Shown is the Pfeiffer Hall dormitory for men.

A c.1895 photograph depicts Stone Hall on the campus of old Atlanta University. It was in this building that W.E.B. DuBois received some of the inspiration for his 1903 classic, *The Souls of Black Folk*. He maintained an office here during his first stint at Atlanta University from 1897 to 1910.

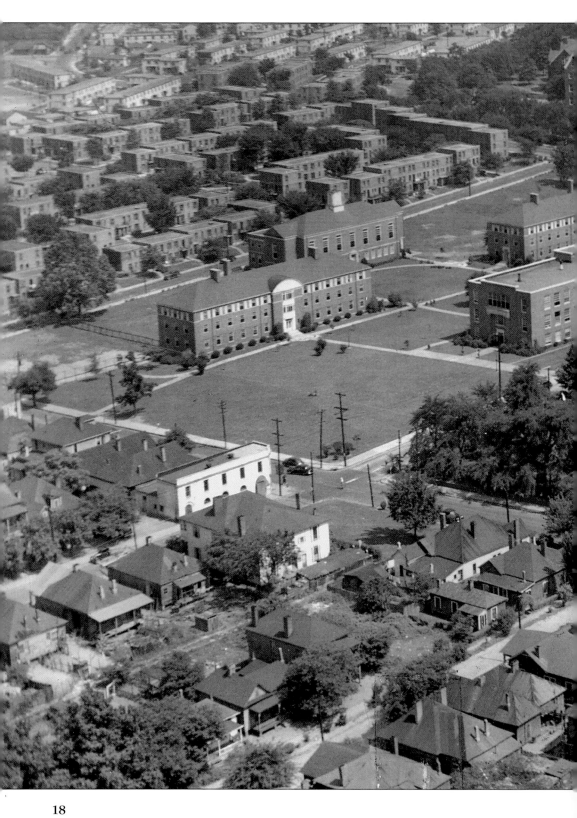

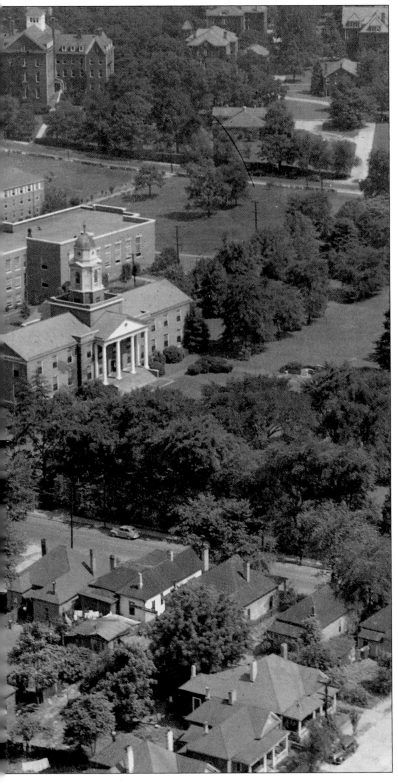

By 1941, Clark University had moved from its southside location to join the other Atlanta colleges. Shown is a c.1942 aerial view of the schools, with Clark College to the left, Atlanta University in the middle, Morehouse College to the far right, and Spelman College at the top. (Courtesy of Griffith Davis.)

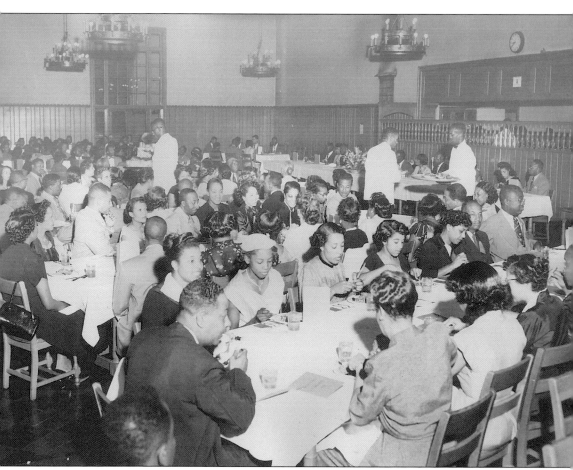
The black colleges of Atlanta were known for their active social and cultural environment. Shown is a c.1952 photo of the students and faculty of Clark College enjoying a banquet in the Crogman dining hall.

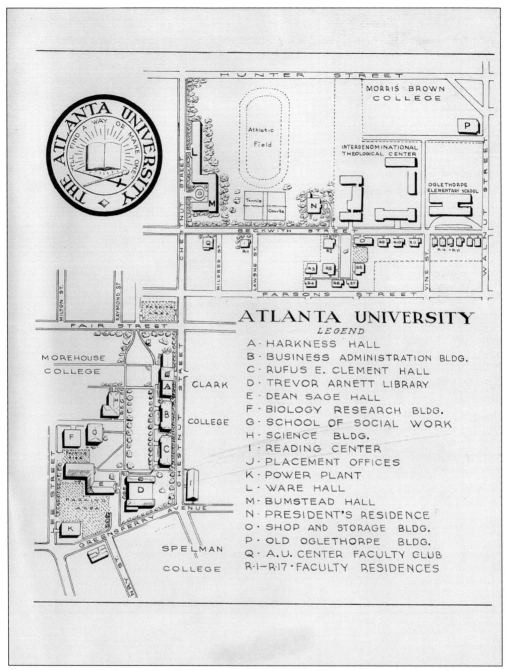

This map of the Atlanta University Center (AUC) illustrates the close physical proximity of the center's member institutions. Note the presence of the Atlanta University Center Faculty Club (Q) and the faculty residences (R1-R17).

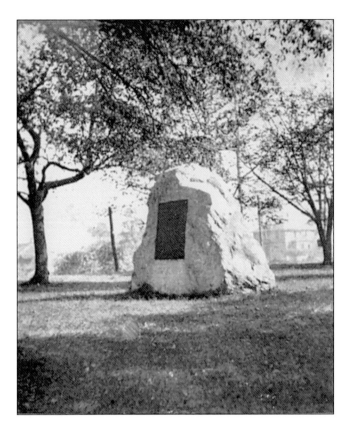

In honor of President Ware, the graduates of Atlanta University petitioned to move his remains to the university's campus. On December 22, 1894, the birthday of President Ware, his body was removed from Westview Cemetery to the campus grounds. The burial plot was located exactly 125 feet from Stone Hall. In a final tribute, the alumni of Atlanta University raised funds to place a stone monument over the grave site. The monument was unveiled at the AU commencement on May 30, 1895.

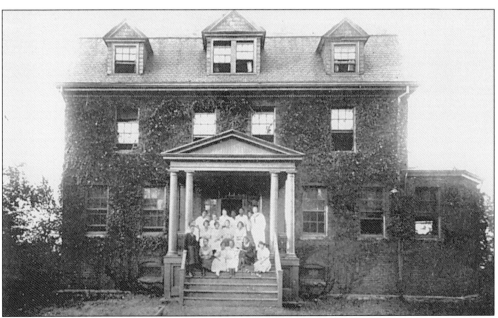

Completed in 1899, Fuber Cottage was the model home for the training of AU women in home economics. The building was officially named the "King's Daughters Model Home and Maria B. Fuber Cottage." (Courtesy of Alexander D. Hamilton, VI.)

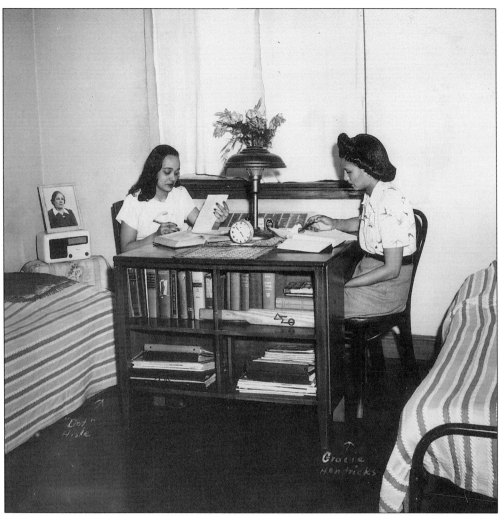

Two Clark College coeds prepare for exams, *c*.1953.

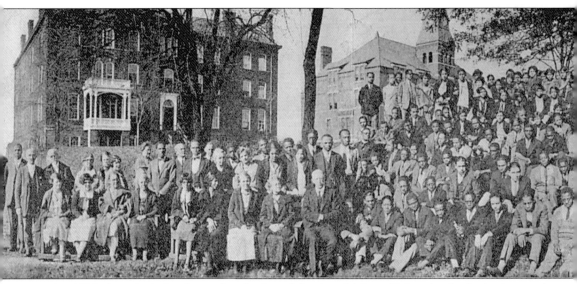
A *c*.1926 photo includes the student body and faculty of Atlanta University. In the background to the far left is South Hall, which was completed in 1870 at a cost of $25,000. It served as a

dormitory for men and also included rooms for recitation and spiritual meditation. (Courtesy of the Grace Towns collection.)

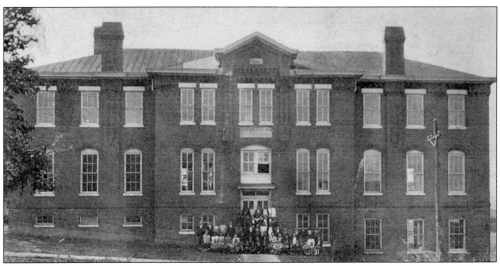

Although heavily involved in the liberal arts, AU added courses in mechanics by the late 1800s. The addition of the Knowles Industrial Building made this possible. Completed in 1884, this facility, according to the *Boston Advertiser*, was the best and largest building of its type in the South. (Courtesy of the Grace Towns collection.)

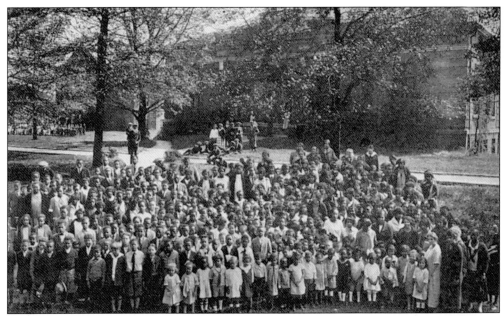

Shown to the far left is the Oglethorpe Building, c.1927. Named for the founder of the state of Georgia, the building was completed in 1905 as a practice school for the training of kindergarten teachers at Atlanta University. In order to erect this structure, the university had to obtain a substantial matching gift for its construction. The university found a benefactor in Mrs. Charles Russell Lowell, the sister of Colonel Robert Gould Shaw, commander of the all-black 54th Massachusetts Regiment. After reading *The Souls of Black Folk* in May of 1903, she decided to answer the financial plea with a gift of $10,000.

Shown is a *c.*1927 photo of the ivy-covered Stone Hall.

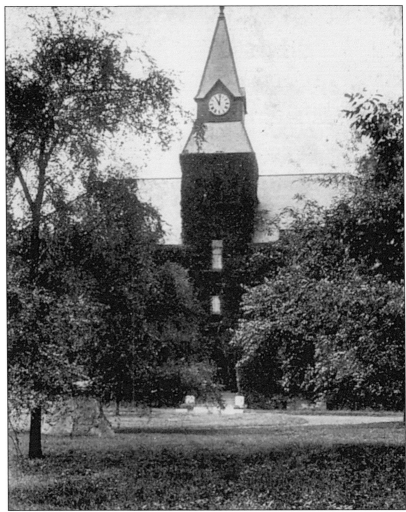

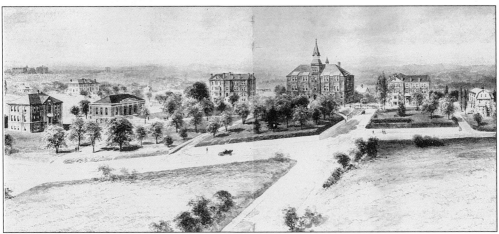

This panoramic rendering of Atlanta University shows the layout of the old AU campus, prior to its relocation in 1929.

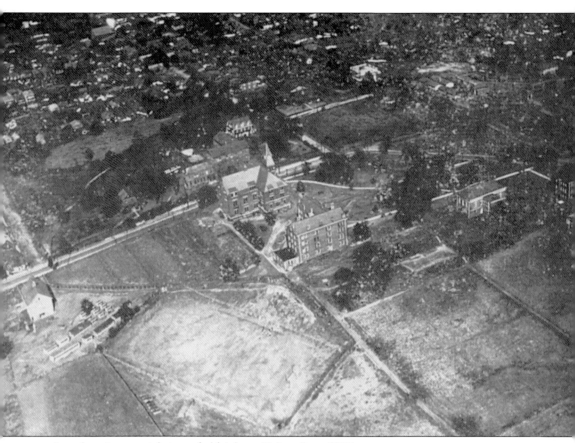
Seen here is an aerial view of old Atlanta University, *c.*1925.

In 1900, the library holdings of Atlanta University began to outgrow Stone Hall; as a result, a new structure was completed in 1906 with a gift from Andrew Carnegie. Shown is the Carnegie Building, named in his honor. By 1900, the only black college libraries to exceed Atlanta University in holdings were Howard and Lincoln Universities. Within the state, only the University of Georgia, Emory, and Mercer exceeded Atlanta.

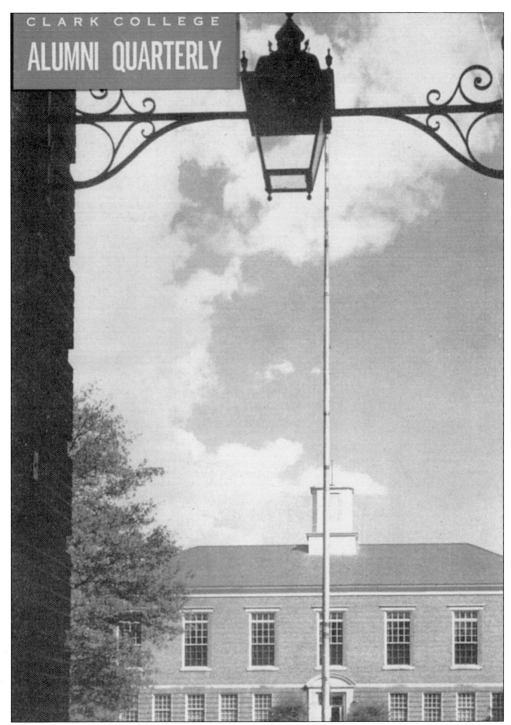

On the cover of this 1956 copy of the *Clark College Alumni Quarterly* is a picture of the east entrance lantern of Haven-Warren Hall. Brawley described it as "the ever beaming lantern of light; a kind of lighthouse signal, always beckoning all students to the center of intellectual action."

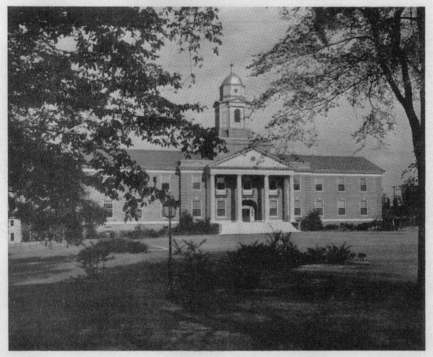

Published quarterly, *The Atlanta University Bulletin* often displayed campus structures on its cover. The administration building of Atlanta University is shown on this July 1935 issue.

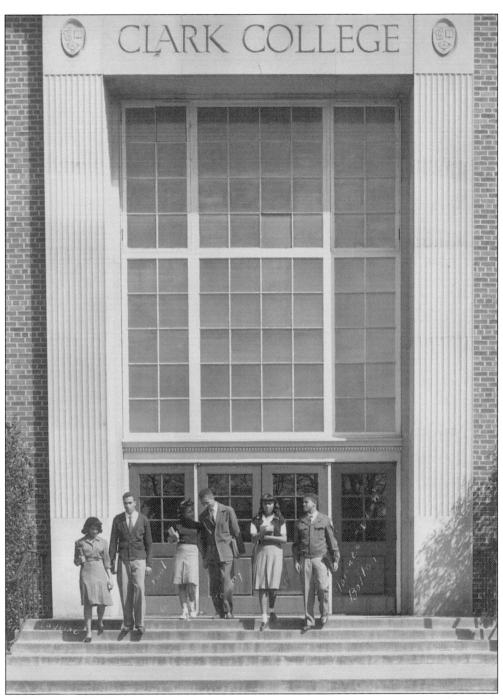

Named after Bishops Gilbert Haven and Henry Warren, Haven-Warren Hall, according to James P. Brawley, "symbolizes the vision, labors and leadership in the development of Clark University for four decades." Brawley also points to the classic entrance as "an impressive symbol of the entrance to a citadel of learning."

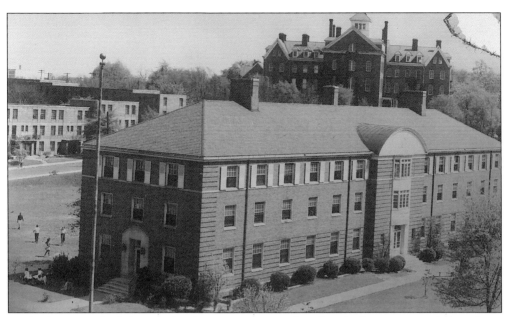

In the foreground of this c.1942 photo is Merner Hall, a female dormitory at Clark College. Pictured in the right background is Giles Hall of Spelman College.

This c.1960 view from the corner of Fair and Chestnut Streets shows Haven-Warren Hall on the campus of Clark College, and Giles Hall at Spelman College, in the background to the left.

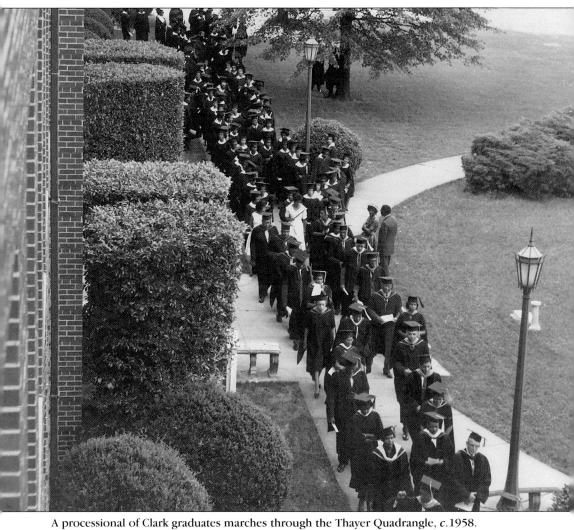
A processional of Clark graduates marches through the Thayer Quadrangle, c.1958.

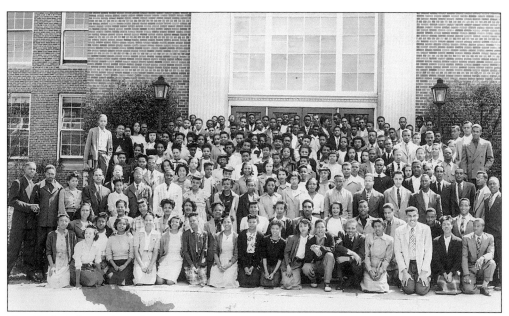
The Clark College Class of 1950 is pictured on the steps of Haven-Warren Hall.

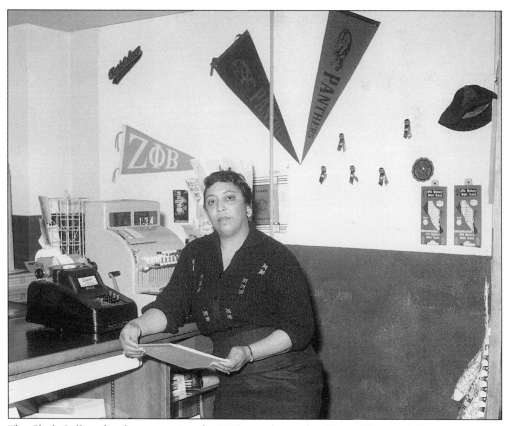
The Clark College bookstore, pictured c.1952, was housed in Haven-Warren Hall.

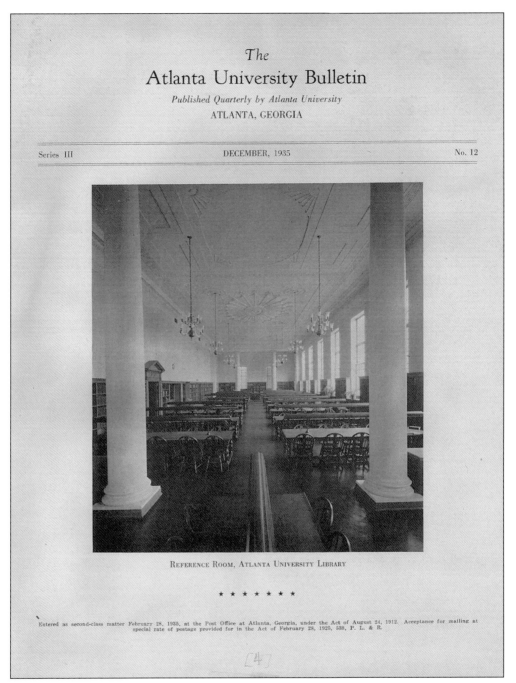

Pictured on the cover of the December 1935 issue of the *Atlanta University Bulletin* is the reference room of the AU Library.

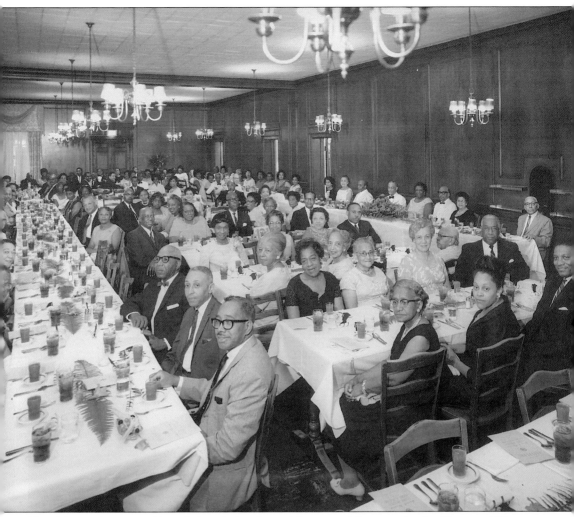

The Atlanta University Alumni Association hosted its annual banquet in the Bumstead-Ware cafeteria, *c.*1965.

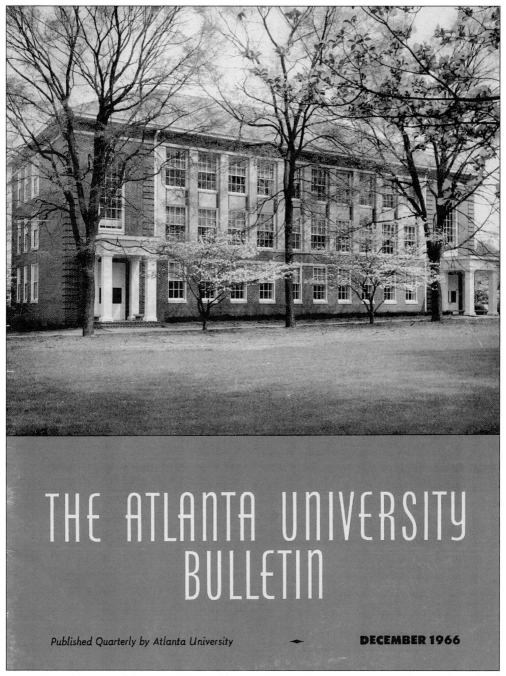

Pictured on the cover of the December 1966 issue of the *Atlanta University Bulletin* is the School of Education, which was dedicated on October 16, 1966, as Rufus E. Clement Hall.

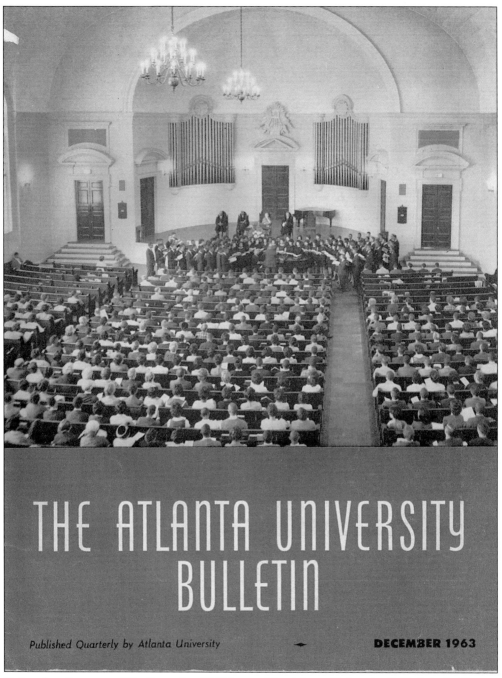

Pictured on the cover of the December 1963 issue of the *Atlanta University Bulletin* is the Charter Day Convocation celebration. It took place in Sisters Chapel on the campus of Spelman College.

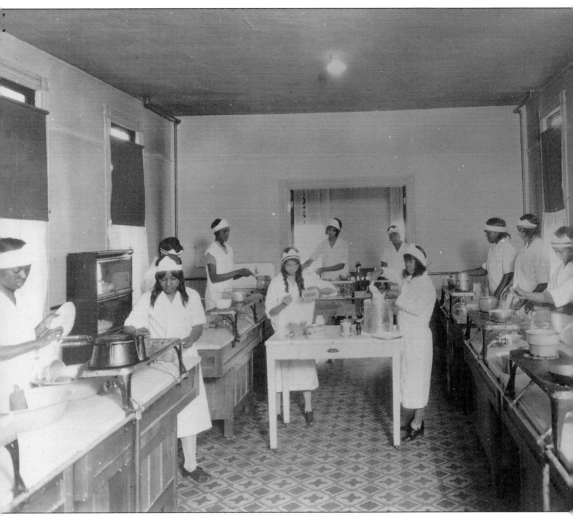
This c. 1930 photo shows the women of the Thayer Home at Clark University. Established in 1883, the Thayer Home was set up by the Women's Division of Christian Services for the training of young women in the domestic sciences. (Courtesy of the Mentor, 1959.)

Two

Administrators and Scholars

A college is no stronger than its faculty.
—Benjamin E. Mays

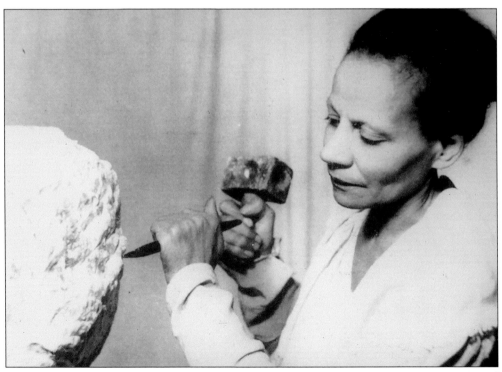

Elizabeth Prophet, a member of the fine arts faculty of the Atlanta University System, achieved a distinguished reputation as a sculptor, both domestically and internationally. Her works are included in the permanent collection of the Museum of the Rhode Island School of Design and in the Mrs. Harry Payne Whitney collection of New York.

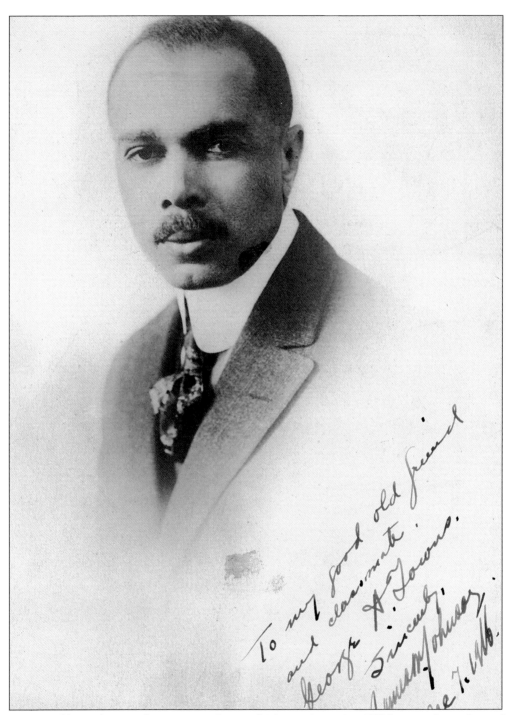

James Weldon Johnson, illustrious graduate of Atlanta University (1894), was the author of the Negro anthem, "Lift Every Voice and Sing." Additional writings of Johnson include *The Autobiography of an Ex-Colored Man*, *God's Trombones*, and *Black Manhattan*. Dr. Johnson served as secretary for the NAACP and professor of creative literature at Fisk University. For two years prior to his death, he was a visiting professor of literature at New York University.

The Atlanta University Bulletin

Published Quarterly by Atlanta University

ATLANTA, GEORGIA

Entered as second-class matter February 28, 1935, at the Post Office at Atlanta, Georgia, under the Act of August 24, 1912. Acceptance for mailing at special rate of postage provided for in the Act of February 28, 1925, 538, P. L. & R.

| SERIES III | JULY, 1936 | No. 15 |

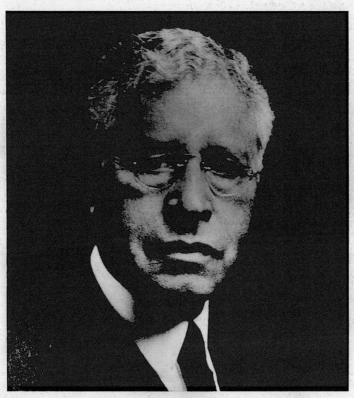

JOHN HOPE
1868–1936

President, Morehouse College, 1906-1931
President, Atlanta University, 1929-1936

John Hope (1868–1936) served as president of both Morehouse College from 1906 to 1931 and Atlanta University from 1929 to 1936. He was also the first president of the Atlanta University System. Hope was a member of Phi Beta Kappa, Alpha Phi Alpha, and Sigma Pi Phi.

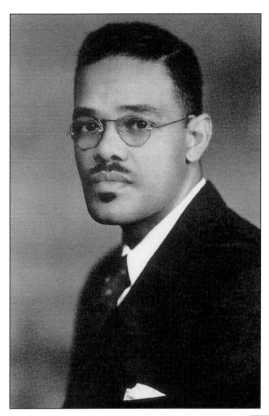

In 1937, Rufus Early Clement was selected by a unanimous vote of the board to succeed John Hope as president of Atlanta University. Clement was 37 years old when he assumed office. Prior to arriving at Atlanta University, Clement was the Dean of Louisville Municipal College for Negroes (a part of the University of Louisville). In addition to his administrative duties, he was an author and contributor to many scholarly journals such as the *Phylon*, The *Journal of Negro Education*, and the *Journal of Educational Psychology*. He was elected to Phi Beta Kappa by Brown University in 1957, and was listed in *Who's Who in America*.

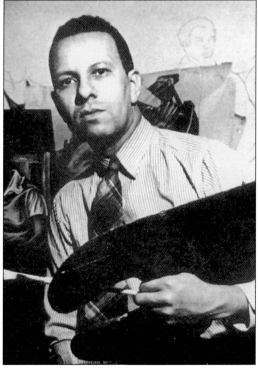

Hale Woodruff is best known for his artistic murals displayed in the libraries of Atlanta University (now Clark Atlanta) and Talladega College. He was invited by Dr. John Hope to join the faculty of Atlanta University in 1930. Woodruff first studied at John Herron Art Institute; in addition, he studied in Paris at the Modern Academy. It was during this three-year stint that Woodruff was encouraged by many artists, including Henry O. Tanner, who at one time was a professor of art at Clark University.

Dr. James P. Brawley's association with Clark University began in 1925, when he became a teacher of education. By 1926, Brawley assumed the position of dean of the college. He held this position until 1941, when he was inaugurated as president of Clark. It was during this time that Clark University relocated from South Atlanta to the Atlanta University System community to become Clark College. Under his leadership, the college grew in stature and accomplishment. Brawley was also one of the founders of the Alpha Phi Chapter of Alpha Phi Alpha Fraternity, Inc.

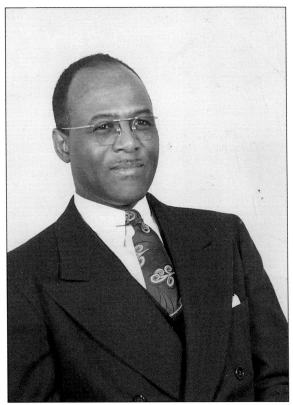

During the 1950s and 1960s, C. Eric Lincoln served as a professor and department chair of Social Relations at Clark College. The Institute for Social Relations was an experimental laboratory devoted to the study of problems arising from racial and religious prejudice. In 1956, while teaching courses in religion and philosophy at Clark, Lincoln was inspired to pursue an in-depth study of the black Muslim movement after reading a senior paper submitted to him on the appraisal of Christianity. As a result, Lincoln went on to write *The Black Muslims in America* (1961).

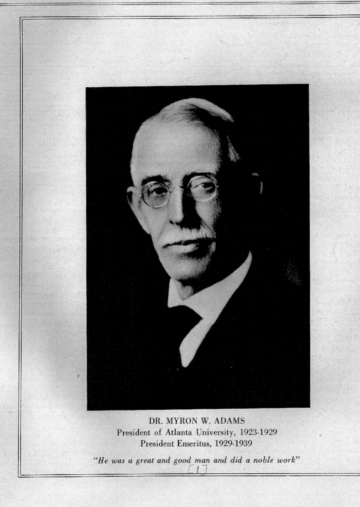

The Atlanta University Bulletin

Published Quarterly by Atlanta University

ATLANTA, GEORGIA

Entered as second-class matter February 28, 1935, at the Post Office at Atlanta, Georgia, under the Act of August 24, 1912. Acceptance for mailing at special rate of postage provided for in the Act of February 28, 1925, 538, P. L. & R.

Series III	JULY, 1939	No. 27

DR. MYRON W. ADAMS
President of Atlanta University, 1923-1929
President Emeritus, 1929-1939

"He was a great and good man and did a noble work"

On the cover of this 1939 issue of the *Atlanta University Bulletin* is a photo of Dr. Myron W. Adams, the fourth president of Atlanta University. Dr. Adams first came to AU in 1889, after a year of graduate study at the Andover Theological Seminary. He went on to serve as president of the University from 1923 to 1929. It was under his leadership that the university signed the agreement of affiliation in 1929, combining Atlanta University, Morehouse, and Spelman. Adams had a long-standing interest in historically black colleges; he spent part of his boyhood years on the campus of Wilberforce University, where his mother and brother were both teachers.

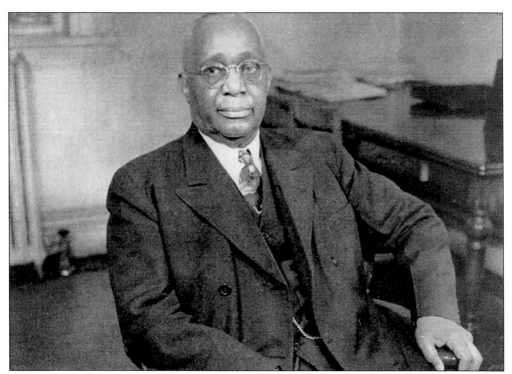

Shown is a 1946 photo of Bishop W.A. Fountain, who served as the chancellor of Morris Brown College. (Courtesy of Skip Mason.)

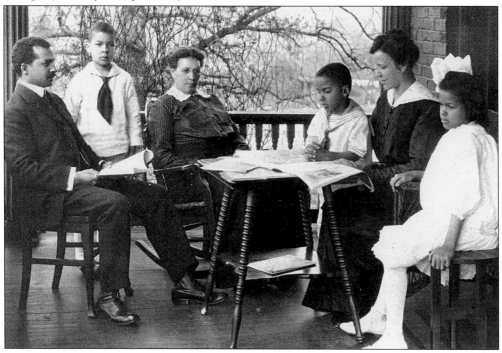

George A. Towns and his family are pictured on the front porch of their home, c. 1900. (Courtesy of Alexander D. Hamilton, VI.)

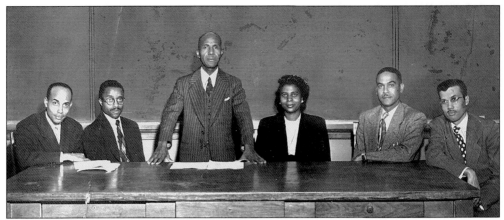

The 1952 Department of Education at Clark College included the following, from left to right: W.S. Bolden, psychology; E. Brantley, education; A.A. McPheeters, dean of the college; P. Dove, teacher training; C. Hamilton, dean of men; and H. Mazyck, student orientation. By 1952, the faculty represented such institutions as Stanford, Chicago, Cornell, Michigan, and Atlanta.

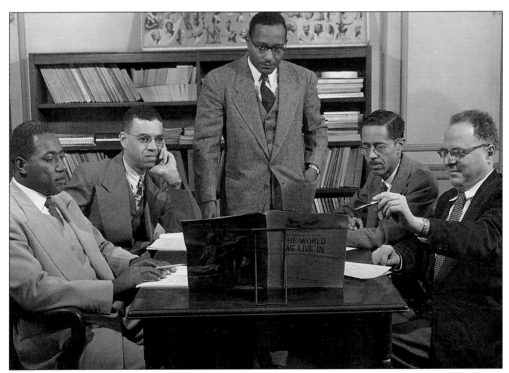

The 1954 Department of Social Science at Clark College included, from left to right, H. Hunter, J. Green, W. Hale, E. Sweat, and R. Rie. Dr. William Hale also served as general president of Alpha Phi Alpha from 1960 to 1962.

Reverend K. Morrison (middle) consults with Professor C. Eric Lincoln (left) and President James P. Brawley (right) during their visit to DePauw University in Indiana, c.1956.

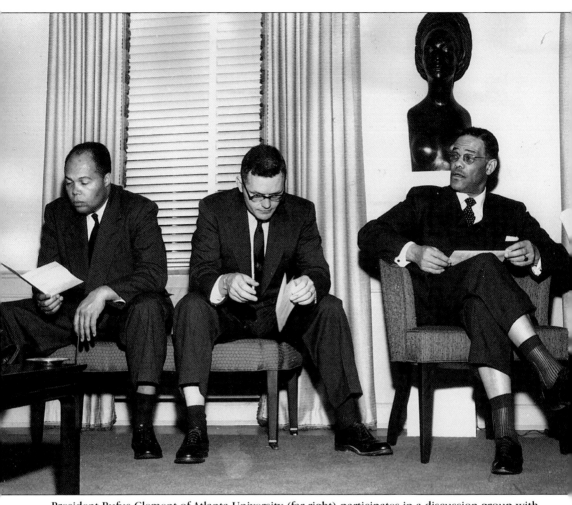

President Rufus Clement of Atlanta University (far right) participates in a discussion group with faculty, c.1964.

I never cease to be amazed that wherever I move around the country, the most relevant

Three

ALUMNI

and effective black leaders are alumni of predominantly Black colleges. This is all the more amazing when you consider the meager resources with which these colleges operate. If the problem of our cities are solved, if an urban education is to emerge, if health and welfare services are to be equitably distributed, the leadership is most likely to come via these institutions.

—Andrew Young

Pictured is a charter granted by the National Alumni Association of Atlanta University to the Atlanta Chapter. The charter was issued on October 15, 1978.

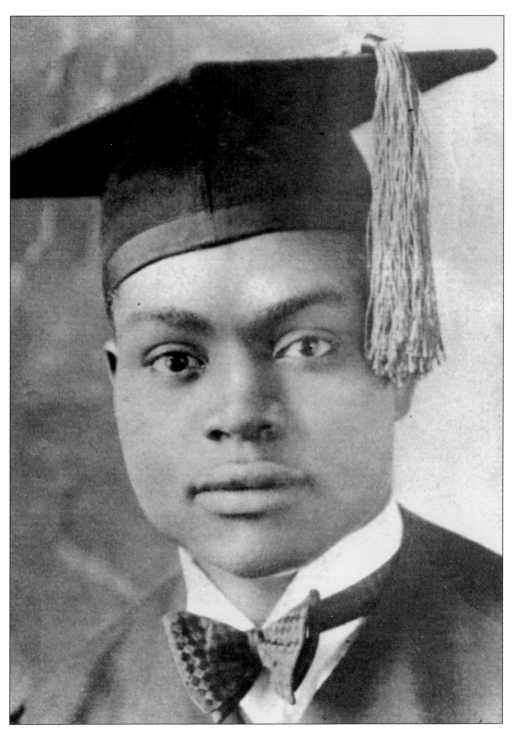

Marquis Lafayette Harris graduated *cum laude* and valedictorian from Clark University in 1928. He went on to become the first African American to receive a Ph.D. from Ohio State University in 1933. In 1936, Harris was appointed president of Philander Smith College. He was also a charter member of Alpha Phi Alpha at Clark.

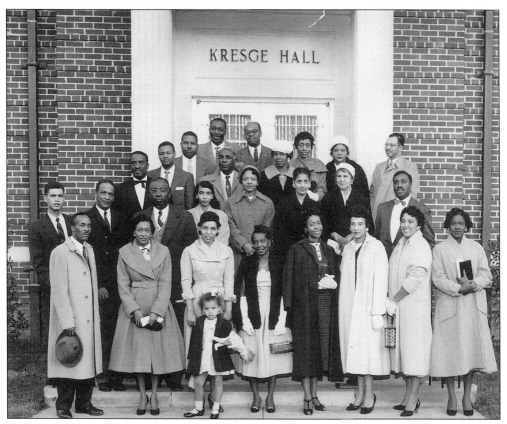

Shown is a *c.*1956 photo of an alumni group at Clark College. Alumni groups traditionally meet on campus. This photo was taken on the steps of Kresge Hall.

AU alumni often hosted their annual banquet on the campus of the university in the Bumstead-Ware dinning hall. Pictured is a *c.*1964 photo of this event.

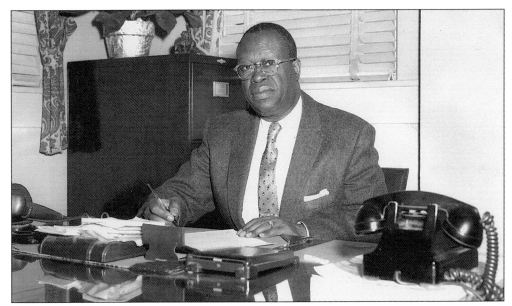

Dr. John J. Seabrook, a Clark alumnus, held the position of college president at both Claflin University in South Carolina and Huston-Tillotson College in Texas. In addition to holding these positions, Dr. Seabrook served as the dean of men at Langston University in Oklahoma and professor of Philosophy at Morgan State College in Maryland.

A group of alumni, family, and future graduates of the Atlanta University Center is shown in this *c.* 1957 photo.

ATLANTA UNIVERSITY.

Atlanta, Georgia, January 20, 1902.

DEAR FELLOW-GRADUATE :—

The Alumni Association of Atlanta University has voted that, in appreciation of his long period of service as teacher and of his unswerving devotion to the development of Negro manhood and to principles upon which the University is founded, a painting be made of President Horace Bumstead, and that it be presented to the Trustees of the University at the next Commencement. President Bumstead's administration has been filled with peculiar obstacles; it has been his hard lot to withstand the prejudice and the *craze* that would shatter the ideal set up by the late President Ware. Shall we not consider it a high privilege to honor in this way the last one of the Old Guard who is now with us and whom we have not honored in this way?

The committee that was appointed asks, therefore, that you send AT YOUR EARLIEST CONVENIENCE, or not later than April 15, one dollar ($1.00) to be used for the purpose mentioned above, and that you urge all of the graduates and undergraduates to do the same. Kindly forward the addresses of any undergraduates you may know.

Yours for Alma Mater,

Committee
- L. B. MAXWELL,
- MRS. A. E. HERNDON,
- J. R. PORTER,
- B. R. WILSON,
- G. A. TOWNS, Chairman.

Pictured is a 1902 appeal letter to AU alumni requesting funds for a painting of President Horace Bumstead to be presented the trustees of the university. Each alumnus was asked to give one dollar in the fund-raising effort.

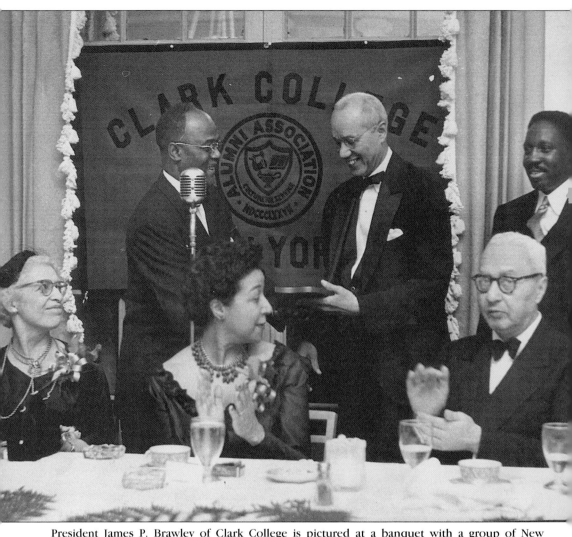
President James P. Brawley of Clark College is pictured at a banquet with a group of New York alumni, *c.* 1964.

Four

FRATERNITIES AND SORORITIES

GOODWILL is the monarch of this house. Men, unacquainted, enter, shake hands, exchange greetings, and depart friends. Cordiality exists among all who abide within . . . in fact, I am the college of friendship; the university of brotherly love; the school for the better making of men.

—Sidney P. Brown

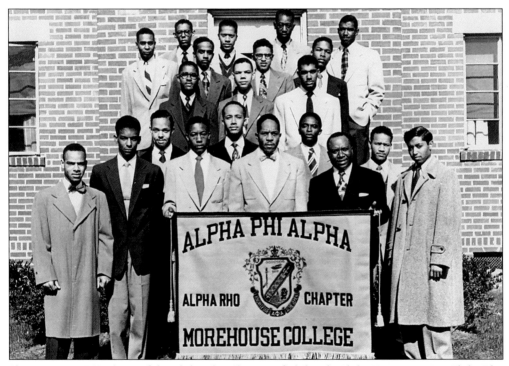

Shown is a c.1950 photo of the Alpha Rho Chapter of Alpha Phi Alpha Fraternity, Inc. Alpha Rho was established on the campus of Morehouse College, January 5, 1924. The chapter was installed by Oscar G. Brown and Norman L. McGhee. Prior to 1924, college men from Atlanta University and Morehouse were initiated into the Eta Lambda Chapter. (Courtesy of Skip Mason.)

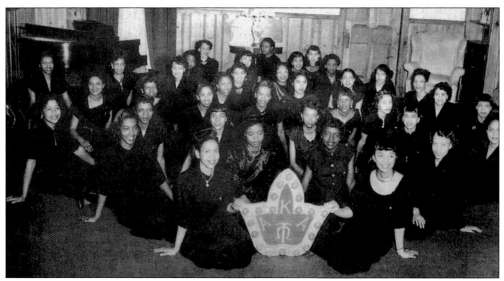

On May 21, 1930, Alpha Kappa Alpha was established on the campus of Clark University with 12 charter members. Shown is a c.1951 photo of the Alpha Pi Chapter of Clark College.

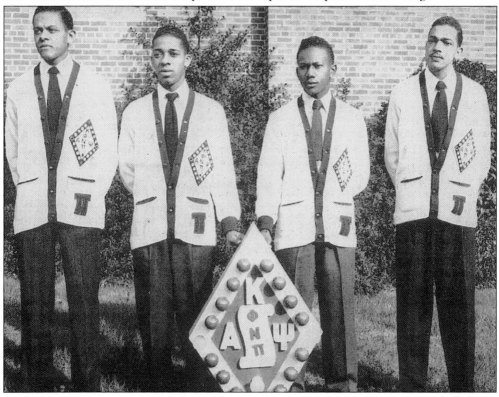

Although the fraternity movement began as early as 1926 on the campus of Clark University, Kappa Alpha Psi did not make its appearance until November 23, 1948. Prior to 1948, Clark men interested in Kappa were initiated into Morehouse College's Pi Chapter. Shown is a c.1948 photo of the newly initiated Kappas of Clark College. Pictured from left to right are Donald Fletcher, David Puckett, William Hunter, and Cleveland White.

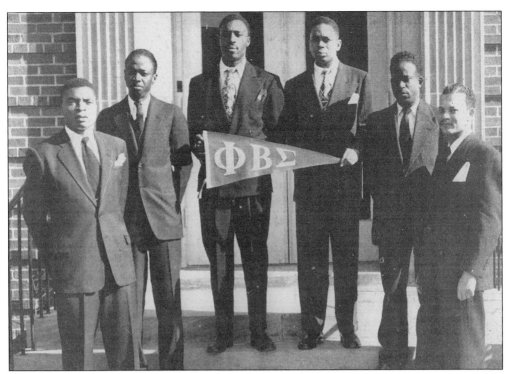

These 1948 members of Phi Beta Sigma Fraternity, Psi Chapter, are, from left to right, Alfred Eason, James Gwyn, Virgil Scott, Simon Snell, Swain Watters, and Dennis Wooding. Psi Chapter was founded on the campus of Clark University in 1937.

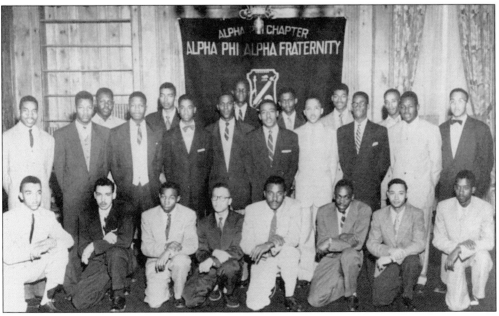

Pictured are the 1953 members of Alpha Phi Alpha at Clark College. The Alpha Phi Chapter at Clark was founded on January 28, 1927, by E. Luther Brookes, Matthew S. Davage, and James P. Brawley.

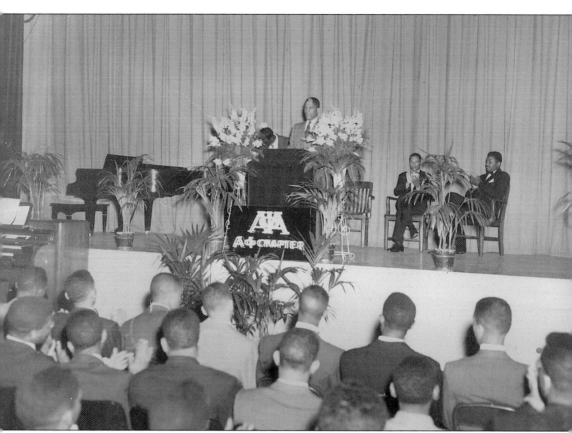

In this c.1950 photo, Attorney Belford V. Lawson Jr. gives a lecture for the members of Alpha Phi Alpha in the Atlanta University complex. This event was hosted by the Alphas at Clark College. Lawson taught and coached football at Morris Brown College in the 1920s. From 1946 to 1951, he served as the general president of Alpha Phi Alpha.

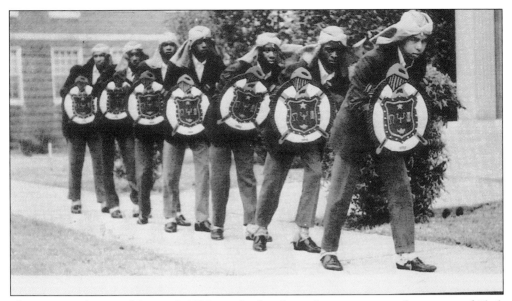

The Beta Psi Chapter of Omega Psi Phi was the first fraternity to appear on the campus of Clark University. The chapter was chartered in 1926. Pictured are the 1965 probates of Omega Psi Phi as they prepare for the "Q-hop."

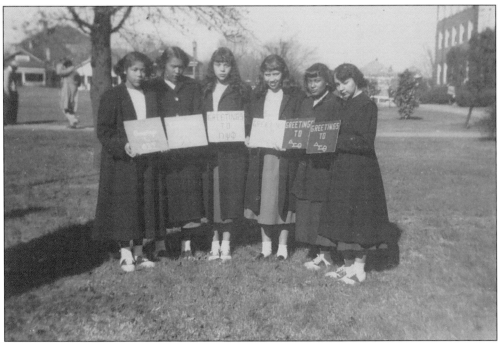

Pictured are the 1947 probates of Alpha Kappa Alpha at Clark College. The probates pay tribute to the other Greek-letter organizations as they hold greeting signs for Sigma, Zeta, Omega, and Delta. (Courtesy of Eula M. Cohen.)

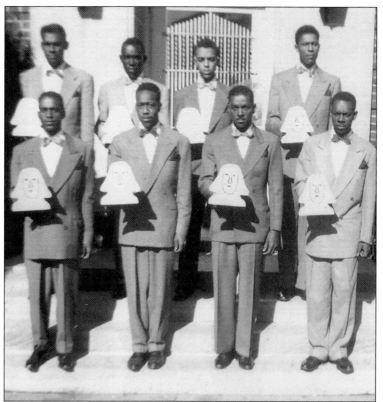

New members of the 1949 Sphinx Club of Alpha Phi Alpha await the approval of their big brothers as they display their Sphinx heads. This photo was taken on the steps of Kresge Hall at Clark College. (Courtesy of Eula M. Cohen.)

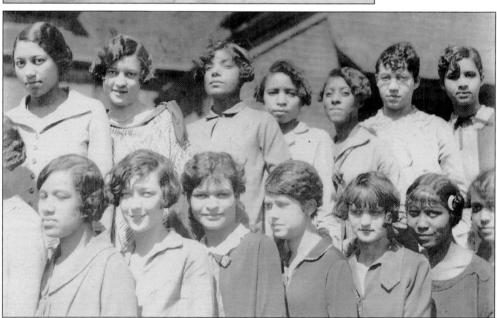

Pictured are the members of the Alpha Beta Chapter of Alpha Kappa Alpha. Founded in 1923 on the campus of Atlanta University, Alpha Beta, like many of the other fraternities and sororities at AU, was short-lived due to the change of AU from an undergraduate institution to a solely graduate institution in 1929. (Courtesy of Alexander D. Hamilton, VI.)

Pictured from left to right are two of the 1949 probates of Alpha Kappa Alpha, Yvonne Abel and Eula Jones. They are seen paying greetings to the men of Alpha Phi Alpha at Clark College.

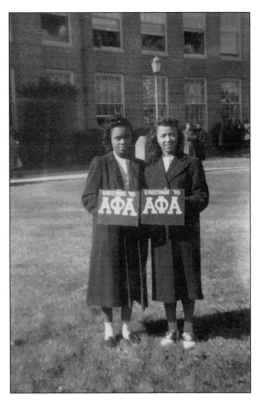

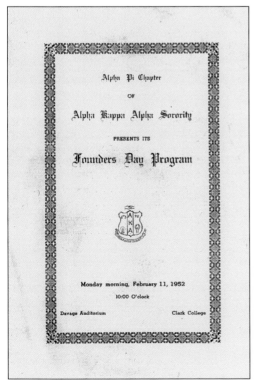

Shown is a 1952 program of the Founders Day for Alpha Kappa Alpha. This event was held in Davage Auditorium on the campus of Clark College.

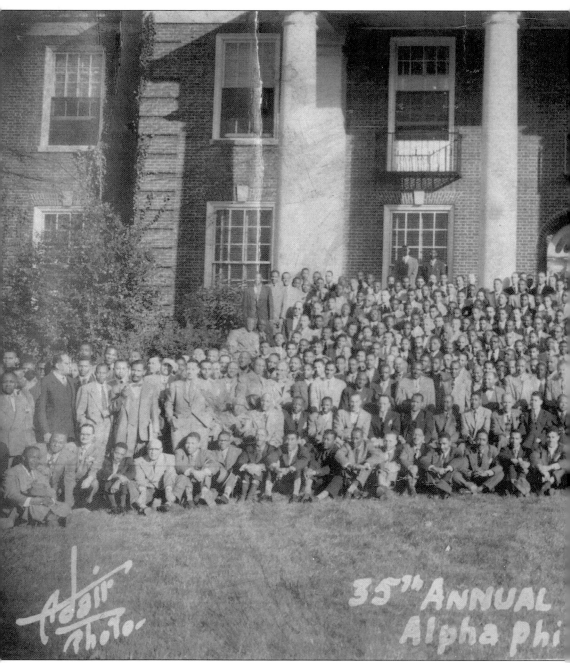

On December 28, 1949, the national body of Alpha Phi Alpha held its 35th Annual Convention on the campus of Atlanta University. The host chapters included Eta Lambda, Alpha Rho, Alpha Phi, and Iota. This convention photo was taken on the steps of Harkness Hall, the administration

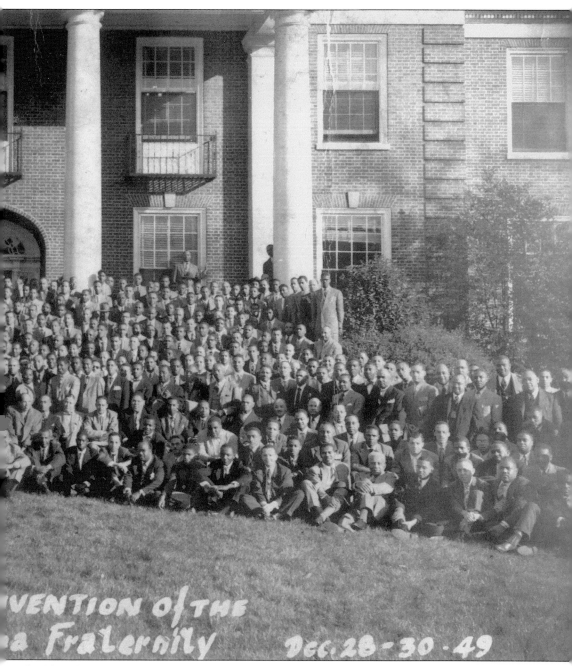

building for Atlanta University. In addition, Morehouse and Spelman Colleges also maintained offices in this building. Today, Harkness Hall serves as the primary administrative building for Clark Atlanta University. (Courtesy of Patrick Johnson.)

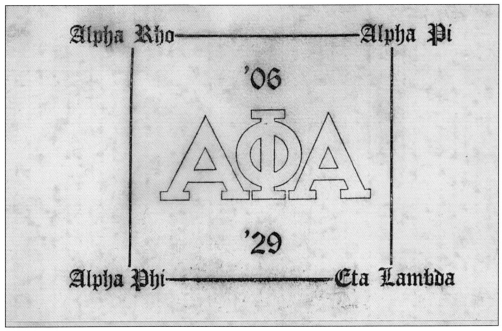

The Atlanta Chapters of Alpha Phi Alpha held a welcome reception and dance to meet the citizens of Atlanta. The event took place on December 27, 1929, at the Roof Garden on Auburn Avenue. Shown is the invitation from this event.

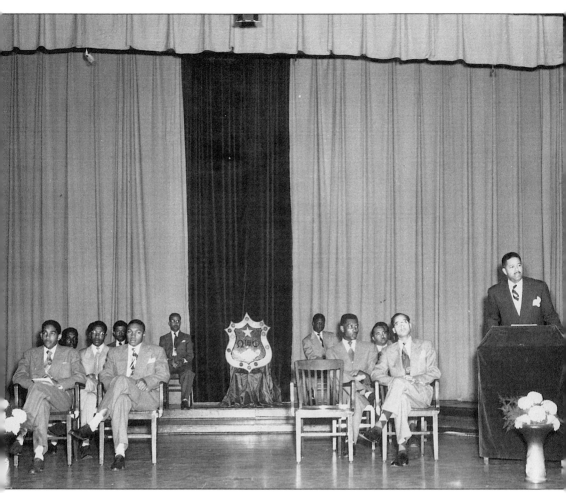

Pictured is a *c.*1952 photo of one of the many cultural programs hosted by the men of Omega Psi Phi. Fraternities throughout the Atlanta University Center were often involved in producing such programs, including lectures, receptions, and formal dances.

On the evening of April 8, 1927, the men of Omega hosted their annual dance at the Roof Garden on Auburn Avenue. The host chapters for this event included Tau of Atlanta University and Beta Psi of Clark University. (Courtesy of the Grace Towns Hamilton collection.)

Pictured is a c.1927 invitation for an informal dance hosted by the Sigma Chapter of Delta Sigma Theta Sorority. The event was held at the residence of Mrs. J.L. Wheeler of Atlanta. (Courtesy of the Grace Towns Hamilton collection.)

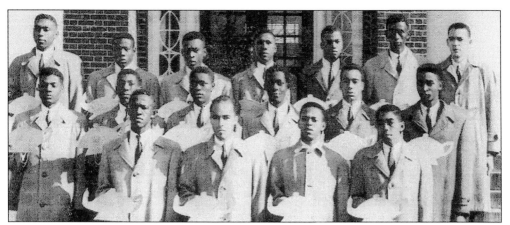

Psi Chapter initiates of Omega Psi Phi Fraternity at Morehouse College are pictured in 1956. Among those initiated was Walter E. Massey, fourth from the left on the first row. (Courtesy of *The Oracle*, 1956.)

The Zeta Phi Beta Sorority hosted an annual awards program on the campus of Clark College, c.1964.

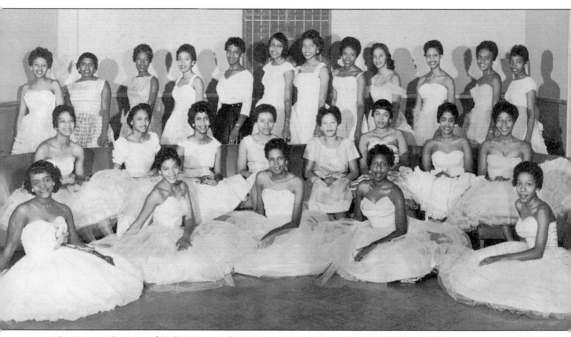

The Sigma chapter of Delta Sigma Theta Sorority is pictured *c.* 1959. Sigma Chapter was organized on the campus of Clark College on May 6, 1931.

Five

CAMPUS CULTURE

The cultural life of the College has been enriched by many and varied program . . . many of these programs were rendered by accomplished artists and speakers.
—James P. Brawley.

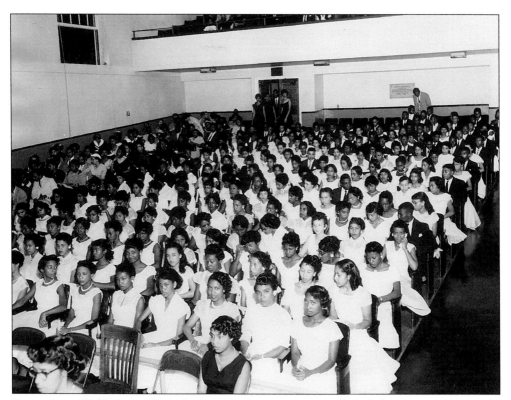

Shown is a *c.* 1964 photo of a freshman induction ceremony at Clark College. "Freshman Week" was born at Clark University in September 1934, but it was not until 1949 that the candle-lighting service was introduced. All freshmen were required to participate in the week's activities. Such an experience afforded the opportunity for all them to become acquainted with the traditions and culture of the university.

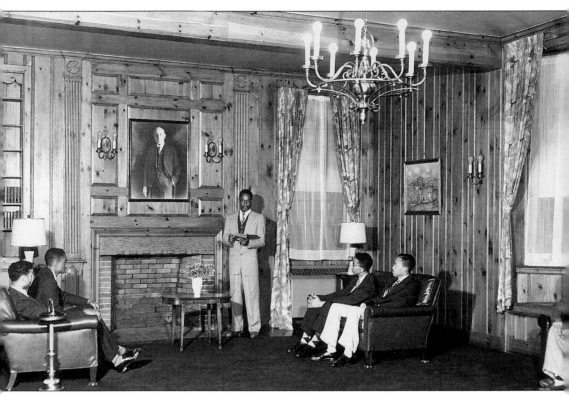

A c. 1953 photo shows a group of Clark men participating in a reading group in the lounge of Pfeiffer Hall. Between the years 1941 and 1959, Pfeiffer Hall was the only male dormitory on campus.

Pictured are Ms. Jennie Douglass and an unidentified beaux socializing on the campus of Atlanta University, *c.* 1926. (Courtesy of Jennie Douglass Taylor.)

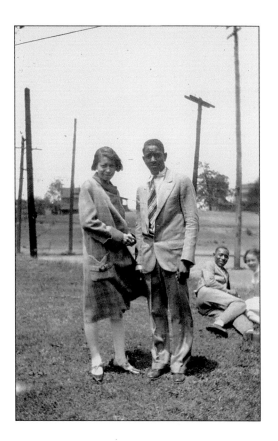

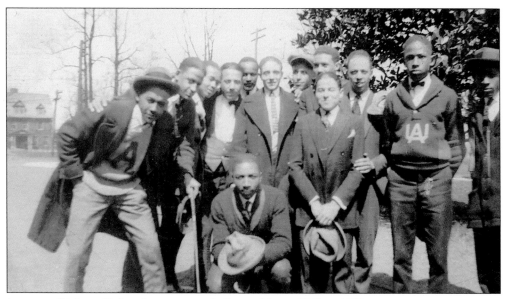

A group of Atlanta University men pose in front of Stone Hall, *c.* 1927.

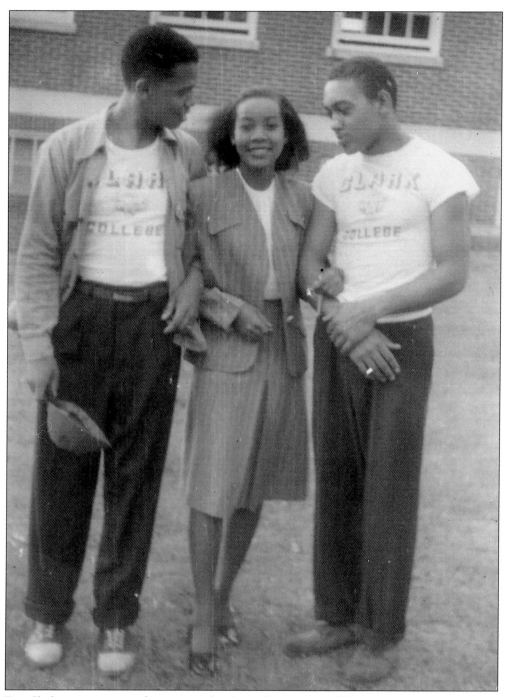
Two Clark men are pictured escorting a lovely coed to class, c. 1951.

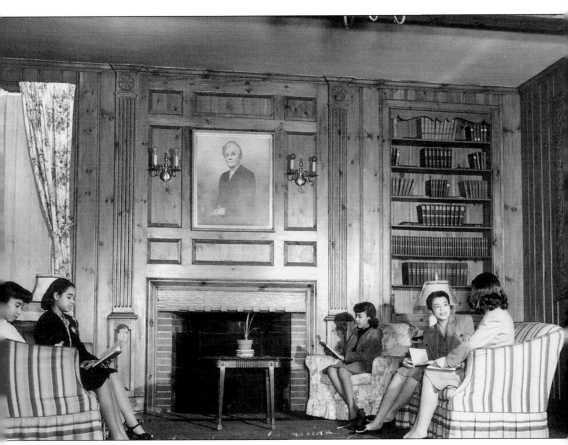

The addition of Merner Hall to the newly relocated Clark campus in 1941 enhanced the renewed spirit of dormitory living. The furnishings and intellectual environment provided an atmosphere for cultural living.

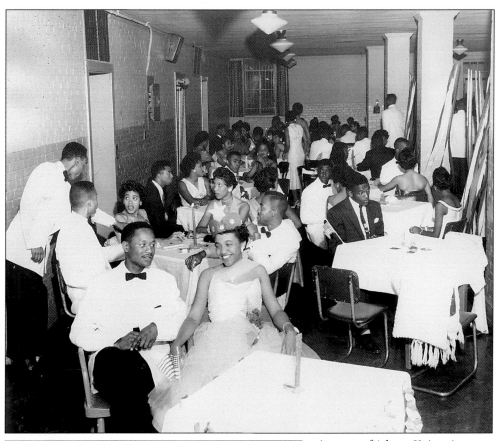

A group of Atlanta University Center students are pictured during an evening dance, c. 1958. The Atlanta colleges often hosted dances that required dinner jackets and formal gowns.

An unidentified student of the Atlanta University Center prepares for the evening events.

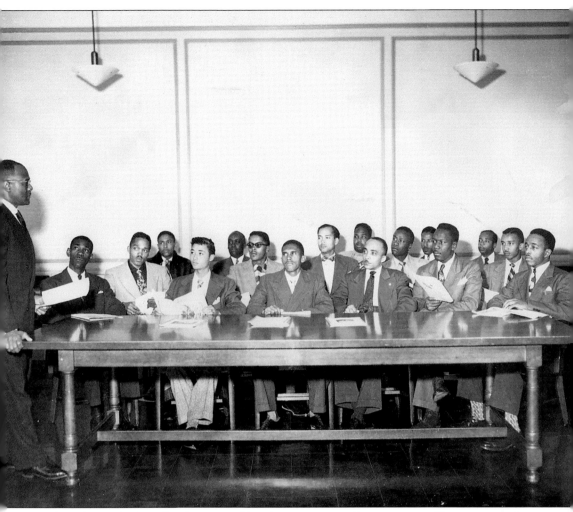

President James P. Brawley is seen addressing a group of young men. For years, such comraderie between young and old was a very important part of the Atlanta student experience. Presidents of the Atlanta schools often addressed students intimately on the various issues of the day. For example, Benjamin E. Mays was well known for his famous chapel addresses in Morehouse's Sale Hall.

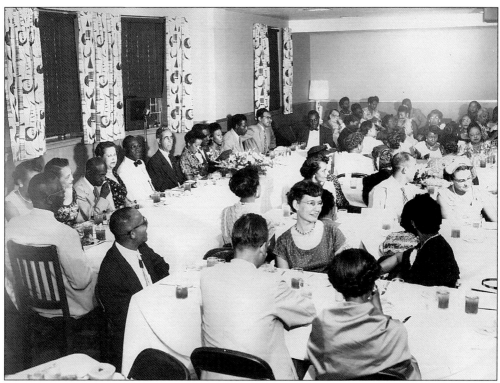

The faculty and administration of Clark College came together for an on-campus banquet in the bottom lounge of Kresge Hall, c. 1958.

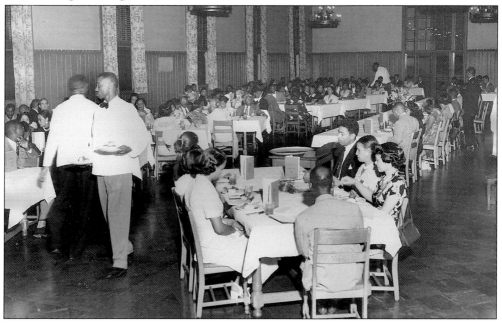

The students, faculty, and administrators of Clark College gather for an evening dinner to celebrate the academic accomplishments of its students. The Crogman Dining Hall was always a popular location for honors banquets.

Mr. and Mrs. George Alexander Towns

request the honour of your presence

at the marriage of their daughter

Grace

to

Mr. Henry Cooke Hamilton

on Saturday afternoon, the seventh of June

at half after five o'clock

Ware Memorial Chapel

Atlanta University

Atlanta, Georgia

Many alumni of Clark, Atlanta, Spelman, Morehouse, and Morris Brown would utilize their beloved alma mater for weddings and receptions. Shown is a program from the wedding of Grace Towns and Henry Hamilton held in the Ware Memorial Chapel on the campus of old Atlanta University. Grace Towns was the daughter of George A. Towns, a member of the Atlanta University graduating class of 1894. (Courtesy of Alexander D. Hamilton, VI.)

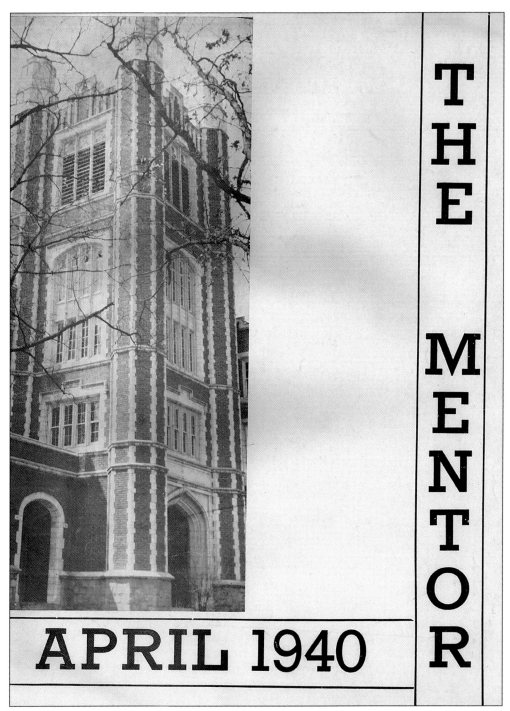

The *Mentor* was a popular publication produced by the students of Clark University. Known as the "Journal of Negro College Life," it received national recognition. The subscription rate for this 1940 copy was 15¢.

Pictured here is a program from a 1923 production of *The Open Door.* This event was hosted by the Atlanta University Club of Washington, D.C., on March 14 and 15 at the Lincoln Theater.

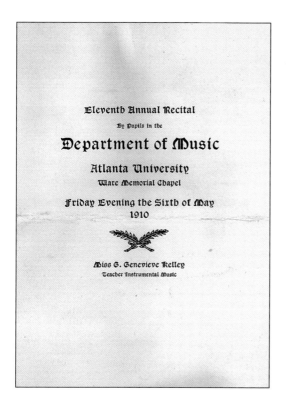

This 1910 program is from the 11th annual recital given by the students of Atlanta University. Some of the selections performed included "Pom*p* and Circumstance;" "Polonaise, Op. 40, No. 1;" "Valse Posthumous;" and "Menuet."

The creative arts have been an integral part of the student and campus culture of Clark College and the other Atlanta University schools. This *c.* 1950 brochure outlines the many cultural activities that took place during the academic year. In addition to student involvement, many adults, faculty, and staff took active roles in the cultural development of the campus.

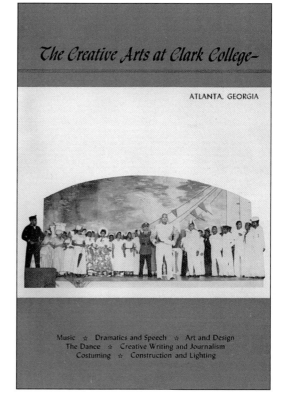

THE BULLETIN
ATLANTA UNIVERSITY

Number 169 Atlanta, Georgia January, 1907

The Atlanta-Calhoun Concert

An event of unusual interest was the concert given in Boston, December twelfth, by Mr. S. Coleridge-Taylor, the eminent musical composer and director, of London, for the benefit of Atlanta University and the Calhoun Colored School. The program was wholly made up of Mr. Coleridge-Taylor's own compositions and was an interesting revelation of his marked ability as a composer. He himself presided at the piano and was assisted by Mr. Henry T. Burleigh of New York with his remarkably sympathetic and appealing baritone voice, and also by the Boston Symphony Quintet under the direction of Mr. Willy Hess who gave admirable rendering to some of Mr. Coleridge-Taylor's finest compositions.

The audience was large, nearly filling Jordan Hall to its full capacity, and was made up mostly of the friends of Atlanta and Calhoun, to whom the tickets had been privately sold. A substantial sum was realized for each of the institutions represented, as was the case with the concert given for them two years ago. By no means the least pleasant feature of these concerts has been the friendly alliance of Atlanta University and the Calhoun Colored School, involved in them, and the incidental opportunity afforded to the friends of each institution to become better acquainted with the work of the other. Mr. Coleridge-Taylor and Mr. Burleigh (the latter for the second time) have put us under great obligations for the services which they have so freely given for the cause so dear to us all.

The vacancy in the Housekeeping Cottage, caused by the illness of Miss M. Pauline Smith and her giving up the work for the remainder of the year, has been filled by the selection of Miss Julia E. Walker. Miss Walker is from Marlboro, Mass., a graduate of the Framingham State Normal School, and with some experience in institution work. She took charge Jan. 2, and we hope for her the best of success.

Miss M. Pauline Smith has continued to gain rapidly, and will probably start for Boston before the end of January.

The Kindergarten Fair

The Gate City Free Kindergarten Association gave a fair early in December to raise money for the support of their schools for colored children. These now number four, a new one having been opened in the fall. The work has also been extended in all of these to help some of the older children who can not find accommodation in the public schools. An hour and a half is given to this extension work every afternoon.

The fair was held at the Colored Young Men's Christian Association, and was well attended for the three nights that it lasted. Many friends sent things to be sold, and the working circles into which the association is organized vied with each other to make it a success. About ninety dollars was raised.

This association, as we have before explained, is an organization which enlists the cooperation of nearly all schools and churches of the Negroes, in the common work of helping some of the least fortunate of the little colored children in the city. The work was undertaken two years ago and has been kept up with admirable enthusiasm. Some generous help has been received from without, but it is primarily a work of the Negroes of Atlanta, prompted by the same humanitarian and Christian motives that prompt similar work among other people.

Prize Speaking

The alumni prizes for excellence in declamation have attracted much interest upon our campus. They were voted by the graduates at the annual meeting last May, being three prizes of $15, $10, and $5 respectively, and being open to all students. So large a number entered the competition that a preliminary trial was held Dec. 8, reducing the contestants from over 30 to 12. The final trial was held Dec. 14, the judges being W. B. Matthews ('90), P. A. Allen, Esq., of the city bar, and Miss Ruth M. Harris ('96). The exercises were highly creditable. The prizes were awarded to Caroline S. Bond (S. P.), Levi P. M. White ('10), and Nathan L. Thomas (S. P.).

Our New Northern Secretary

Mrs. Estelle M. H. Merrill of Cambridge, Mass., who has for many years been well acquainted with the work of Atlanta University and has rendered it many a labor of love in enlisting the interest and aid of northern friends for its needs, has recently accepted an offer to become Northern Secretary of the Institution, giving her whole time to this work. For this she has unusual qualifications in her gifts as a public speaker and as a writer (over the name of Jean Kincaid), as well as in her long experience as a member and officer of various organizations of women, and her warm sympathy with the special forms of educational work for the Negro which Atlanta University is carrying on.

We earnestly bespeak for Mrs. Merrill the kindly cooperation of our northern friends in the work she has undertaken. She is prepared to address churches, Sunday-schools, women's clubs, and other gatherings, giving her latest impressions of our work as based on a recent visit to Atlanta, and may be addressed for that purpose at her residence, 45 Bellevue Ave., Cambridge, Mass.

President Ware's Grandson

On Sunday, January 7th, Alexander Holdship Ware was christened in Ware Memorial Chapel. President Bumstead officiated. The ceremony just preceded the communion service, and, with the association of the time and place, was very impressive.

Above the pulpit platform hangs the portrait of the first president, Edmund Asa Ware, on the right and on the left are the simple but beautiful stained glass windows placed there by the graduates of Atlanta University in memory of President and Mrs. Ware who had for their sakes paid "the last full measure of devotion." In this room, in the presence of teachers and pupils, the grandson of President Ware was, by his successor, President Bumstead, consecrated to the service of God, in a simple and beautiful service arranged for the occasion.

Prof. Towns went to Griffin, to be the Emancipation Day orator in that place.

The *Bulletin of Atlanta University* was a monthly publication highlighting the activities of the university. This 1907 issue is complete with a panoramic sketch of the campus.

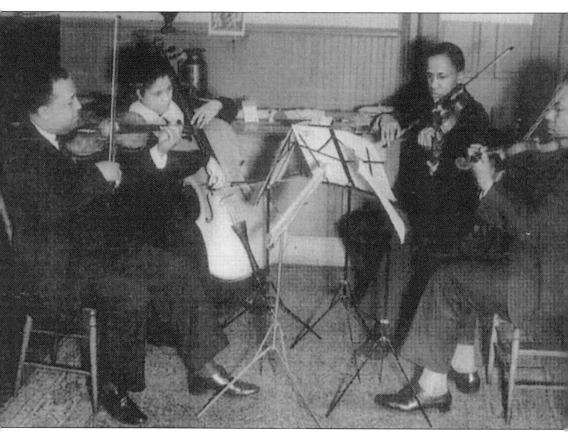

Organized in 1935, The Harreld String Quartet was said to be "the first such organization of its kind at a Negro college." During its operation, the quartet played at a number of institutions and won widespread acclaim. The members of the quartet, pictured from left to right, are as follows: Laurence James, Morehouse Class of 1931, teacher of music at Spelman; Richard Durant of Morehouse; Geraldine Ward of Spelman; and Kemper Harreld, director of music at Spelman and Morehouse Colleges.

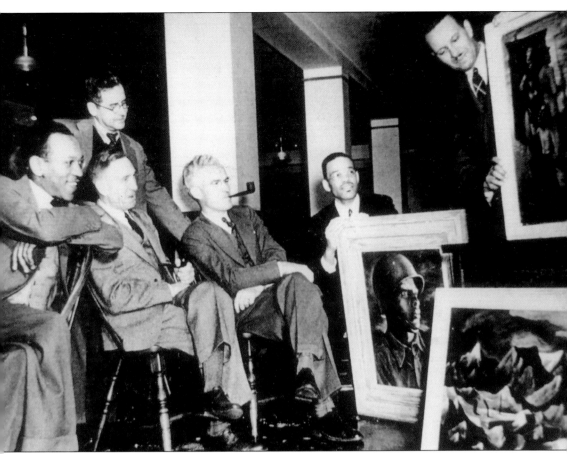

Pictured are the jury and the prize-winning oils from the second annual National Exhibition of Paintings by Negro Artists. From left to right are Charles White, Jean Charlot, Lewis Skidmore, Lamar Dodd, Rufus Clement, and Hale Woodruff. The art competition sponsored by Atlanta University was initiated in 1942 in an effort to stimulate a greater appreciation of painting and, at the same time, give recognition to more black artists scattered throughout the country.

This 1961 program is from the Freshman Orientation Week at Clark College.

The Third Annual Festival of Music and Arts program at Clark College was held in Davage Auditorium on April 28, 1950. The Clark College Rambler Orchestra provided some of the evening's entertainment with selections such as "Take the 'A' Train" and "Body and Soul."

This 1927 program is from a selection of four one-act plays presented by the Dramatic Club and Drama Class of Atlanta University.

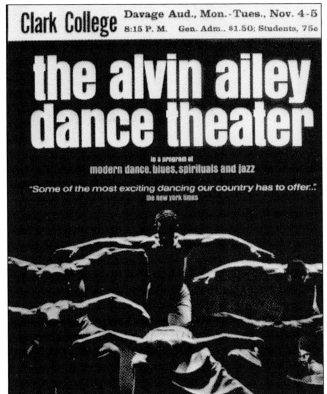

Shown is a handbill from a 1965 performance of the Alvin Ailey Dance Theater on the campus of Clark College.

The Ugly Duckling was one of the many plays put on by the Atlanta University Summer Theater, c.1965. This marked the 32nd season of the AU Summer Theater; other plays that season included *The Unexpected Stranger*, *The Fantasticks*, and *The Glass Menagerie*. The director of the Summer Theater was Dr. B.W. Burroughs, director of the Atlanta-Morehouse-Spelman Players.

ANNUAL CONCERT

Morehouse College

Glee Club and Orchestra

Kemper Harreld, Director

SALE HALL CHAPEL

Friday Evening, Feb. 11, 1927

8:00 O'clock

Mason & Hamlin Piano Used

A 1927 program is pictured from the annual concert of the Morehouse College Glee Club and Orchestra.

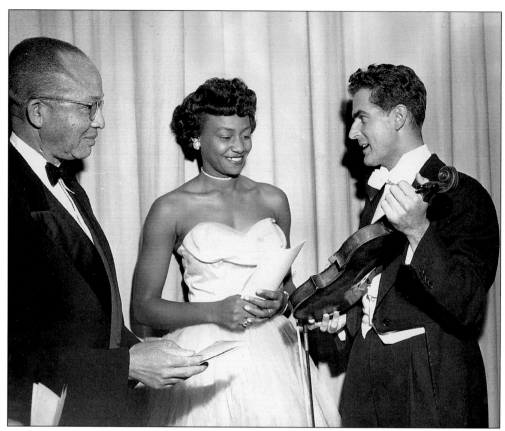

Shown to the far left is Dr. J. de Koven Killingsworth following an evening performance on the campus of Clark College. Dr. Killingsworth was the director of the Philharmonic Choir at Clark and the creator of the Clark Christmas Vesper tradition, beginning in 1924.

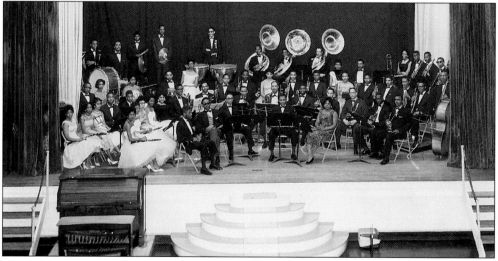

A *c.* 1960 photo was taken of the Clark College orchestra during one of its many annual spring concerts. Many members of this group would go on to head various music programs throughout the Atlanta Public School System.

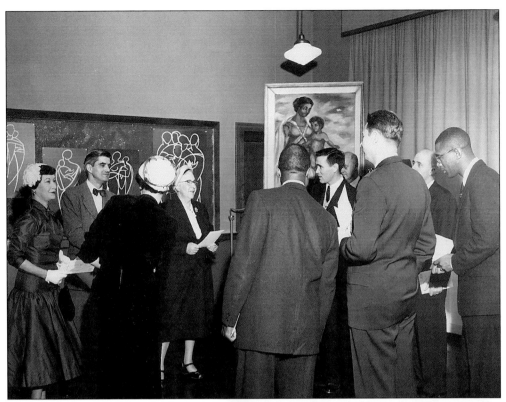

Pictured here is an annual art exhibit during the Clark College Arts Festival, c. 1961.

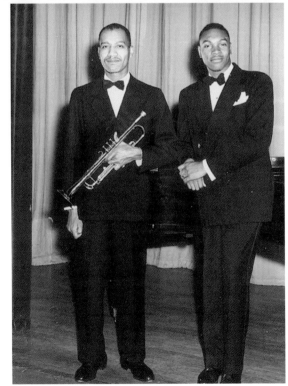

A c. 1965 photo of two unidentified students was taken after a recital.

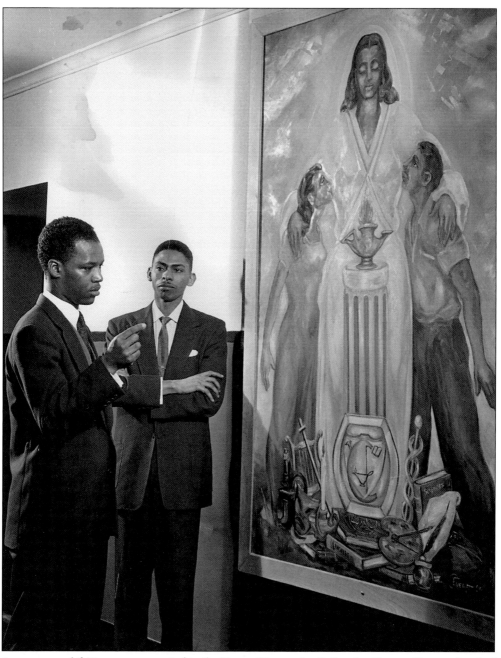

A one-man exhibition was presented in the Haven-Warren Art Gallery by Chestyn Everett, head of the Art Department at Clark College, c. 1954.

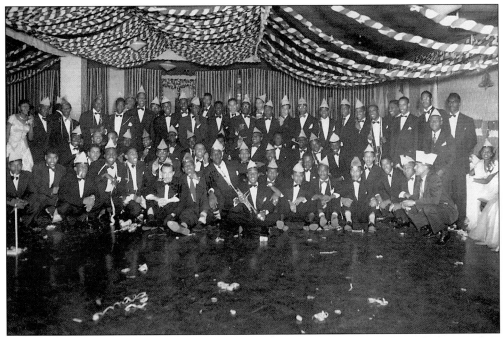

A c. 1953 photo shows one of the many black-tie events hosted by the students of Clark College.

Participating in the annual Clark College Fashion Show c. 1956, from left to right, are Mildred Stennis, J. Raymond Berry, and William Harper. The show was hosted by the Clark College Department of Home Economics.

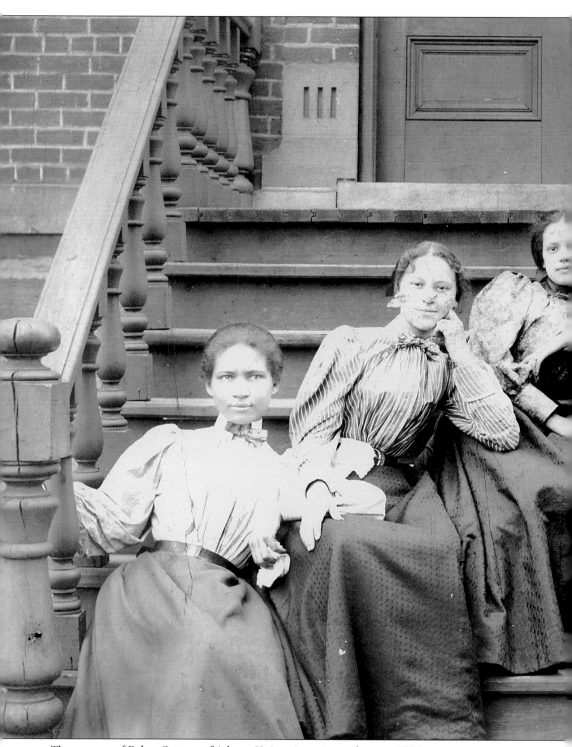

The women of Fuber Cottage of Atlanta University are seen here, *c.* 1890.

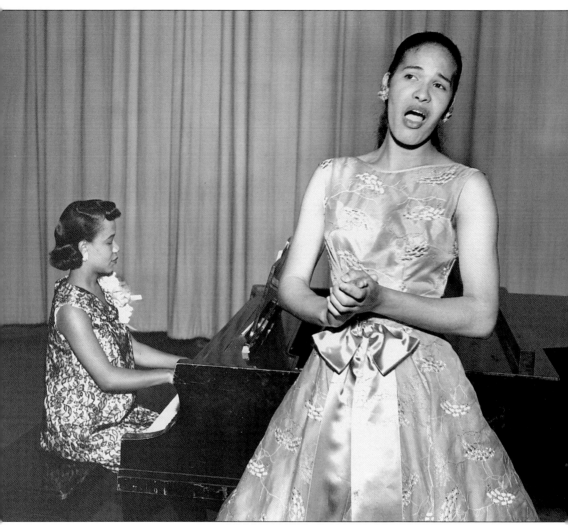

This faculty recital was hosted by the Music Department of Clark College, c. 1954. Seen from left to right are Sarah Phillips and J. Arveres.

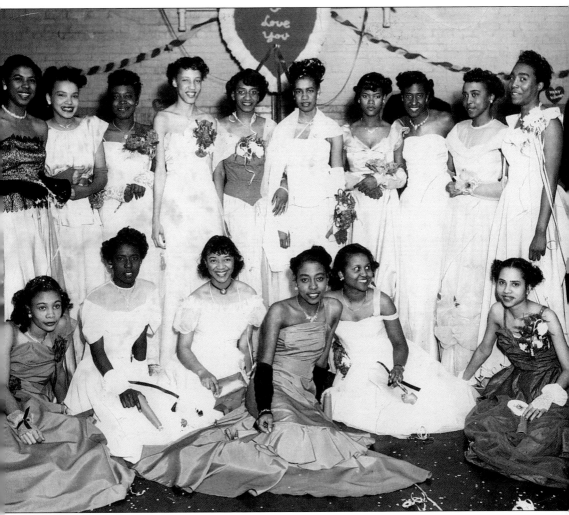

Noted for their annual sweetheart dances, the Bon Bons and Tokyos were one of the most outstanding social groups on the campus of Clark College, c. 1950.

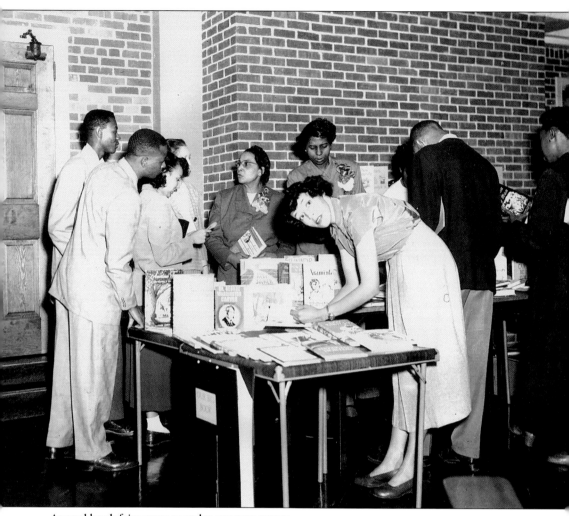
Annual book fairs were popular campus events.

Six
POMP AND CIRCUMSTANCE

The direction in which education starts a man will determine his future life.
—*Plato*

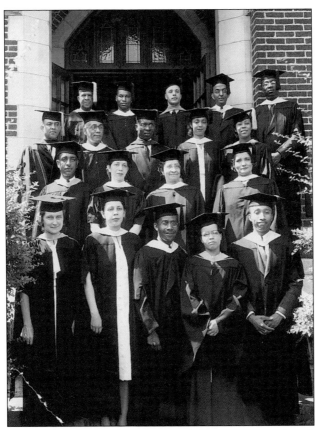

Members of the Clark University faculty of 1940–41 are seen in this photograph.

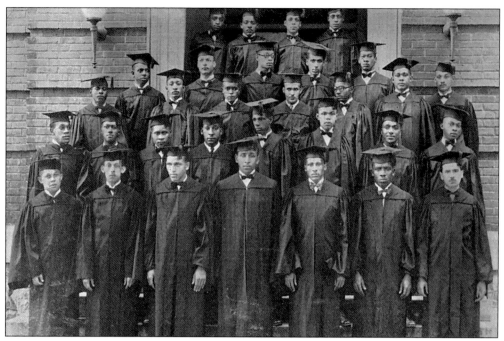
Pictured here is the Morehouse College graduating class of 1927.

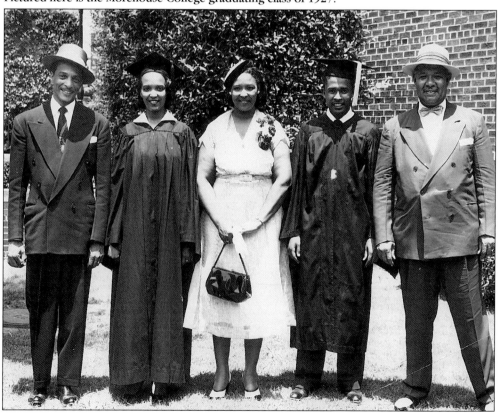
This commencement photo was taken at Clark College, c. 1955.

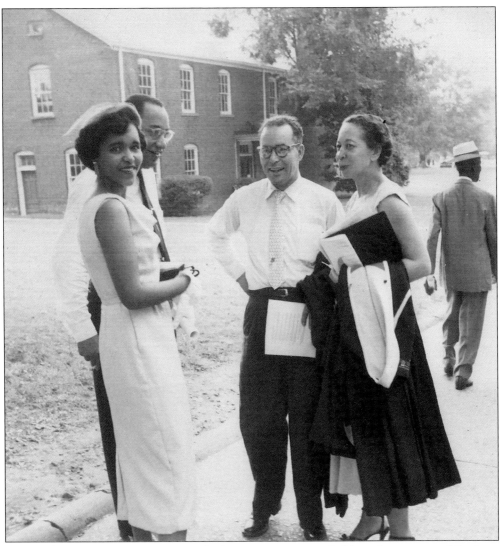

The 1956 Summer Commencement of Atlanta University was held on the campus of Spelman College. From left to right are Mrs. Westerfield, Dr. Westerfield, unidentified, and Mrs. Jennie D. Taylor. (Courtesy of Mrs. Jennie D. Taylor.)

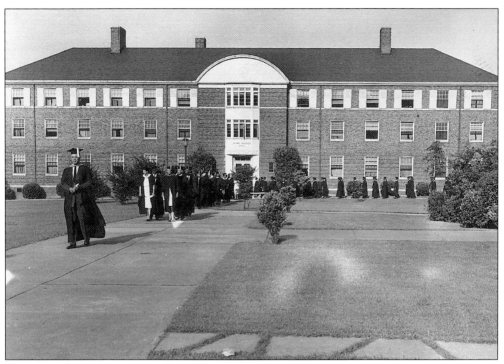
An academic processional through the campus of Clark College took place c. 1945.

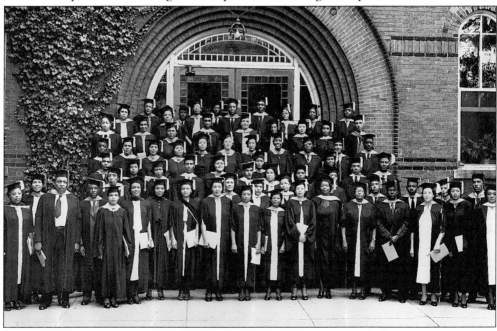
This photo of the 1949 graduating class of Atlanta University was taken on the campus of Spelman College. Before Atlanta University moved from its old campus, commencement exercises were sometimes held in the Ware Memorial Chapel in Stone Hall. However, after the move of Morris Brown to the old AU campus, AU subsequently moved its exercises to Spelman's Sisters Chapel in 1934.

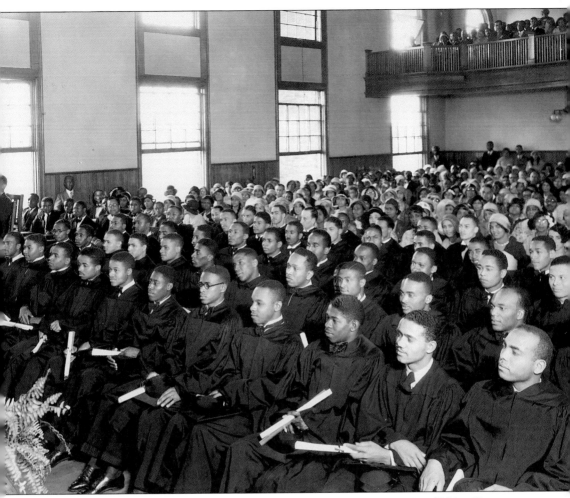

This photo was taken at the Morehouse College commencement in 1931. (Courtesy of Skip Mason.)

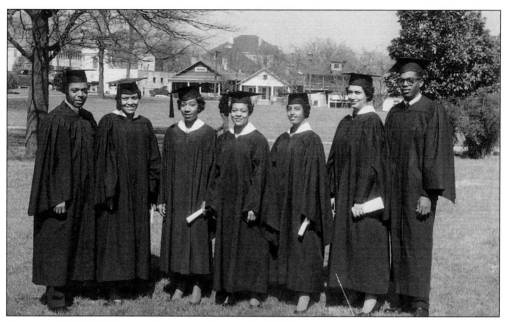

A group of Clark College graduates are pictured c. 1958.

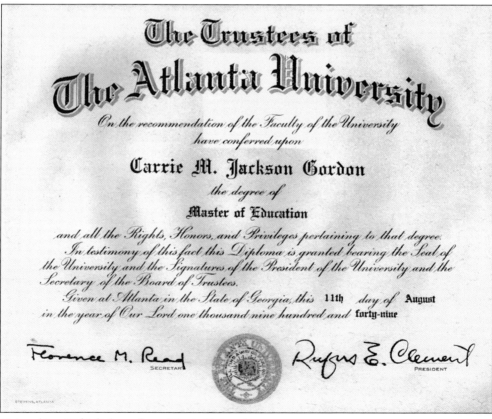

Pictured is a 1949 diploma from Atlanta University.

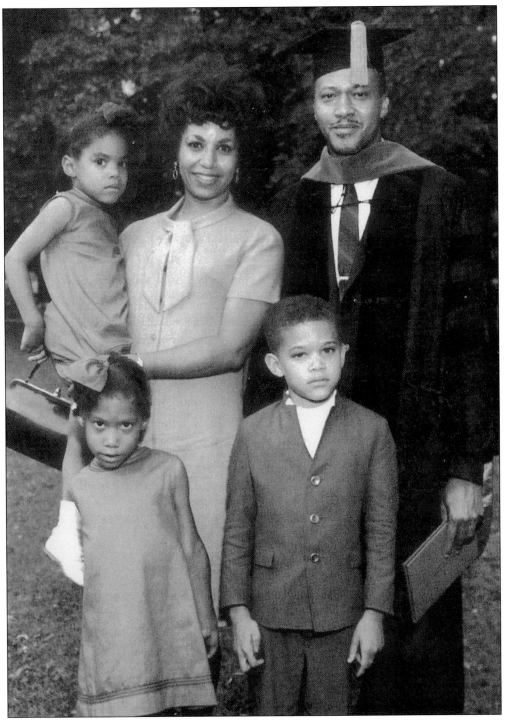

Shown is a photo of Atlanta graduate Dr. Samuel J. Tucker and his family. At the 100th commencement of Atlanta University held on June 2, 1969, Dr. Samuel J. Tucker was the recipient of the university's first doctorate degree. Dr. Tucker is also a graduate of Morehouse College. (Courtesy of the *Atlanta University Bulletin*, July 1969.)

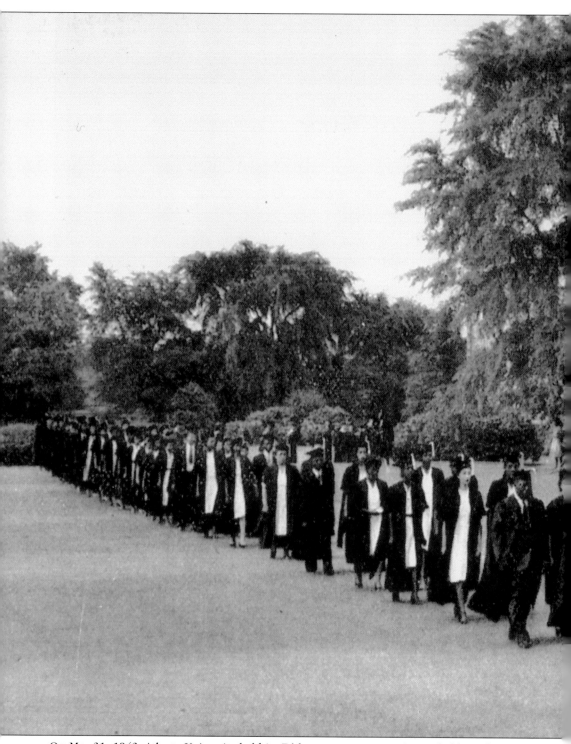

On May 31, 1943, Atlanta University held its 74th commencement—it was held on the campus quadrangle for the first time since 1930. The commencement was highlighted by the conferring of four honorary degrees. The honorees included Mrs. Mary McLeod Bethune, founder of

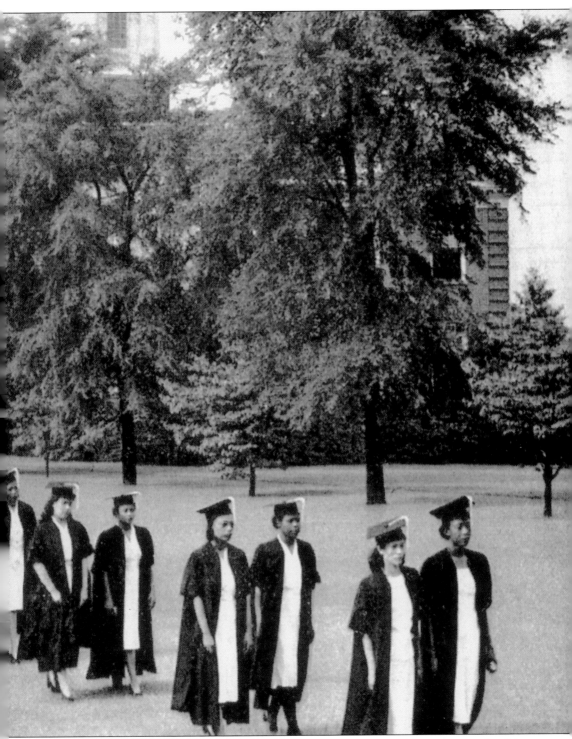

Bethany-Coachman College; Walter F. White, AU class of 1916, secretary of the NAACP; Richard R. Wright, AU class of 1876, president of Citizens Trust Bank of Philadelphia; and Brigadier General Benjamin O. Davis (conferred in absentia).

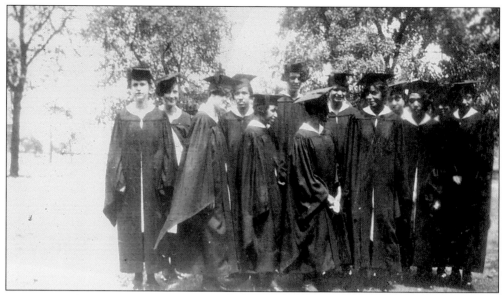
A group of 1927 Atlanta University graduates are pictured here. (Courtesy of Alexander D. Hamilton VI.)

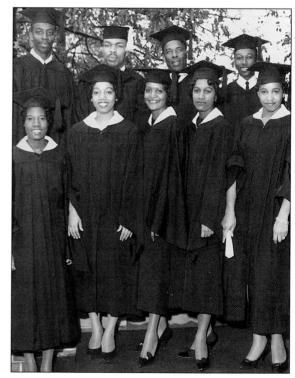

Left: Edith Winbish and Grace Holmes graduated from Atlanta University in 1927. (Courtesy of the Grace Towns Hamilton collection.)
Right: This c.1961 photo was taken of a group of Clark College graduates. Pictured in the back row, second from the left, is James L. Felder. Felder received national attention as a casketbearer during President John F. Kennedy's burial in 1963. (Courtesy of Meca L. Walker.)

Seven

ATHLETICS

"The Black Battalion of Death, The Crimson Hurricane, The Maroon Tigers, The Purple Wolverines, Herndon Stadium, Spillers Field, Thanksgiving Classic, Samuel B. Taylor, B.T. Harvey . . ."

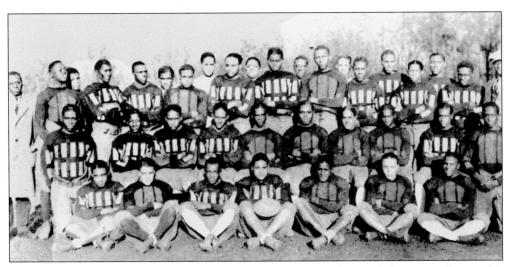

Between the years 1927 and 1929, athletic history was made at Clark. It was during this time in 1928 that the "Black Battalion of Death" became famous for defeating the seemingly invincible "Golden Tigers" of Tuskegee Institute, 13-9. Samuel B. Taylor of Virginia Union and Northwestern coached the team from 1925 to 1929. In 1928, the team shared a two-way tie for the SIAC championship.

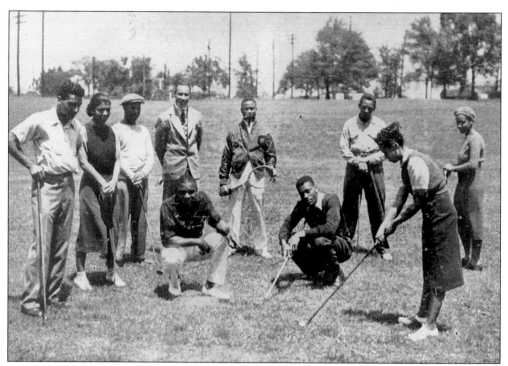

Students tee off on the Clark University golf course, c. 1939. Pictured fourth from the left is Coach Curry. (Courtesy of the Clark University *Mentor*, June 1939.)

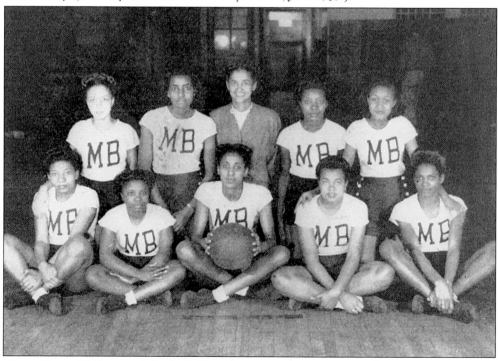

Pictured is the 1946 women's basketball team of Morris Brown College. They played such schools as Clark, South Carolina State, Allen, Benedict, and Tuskegee.

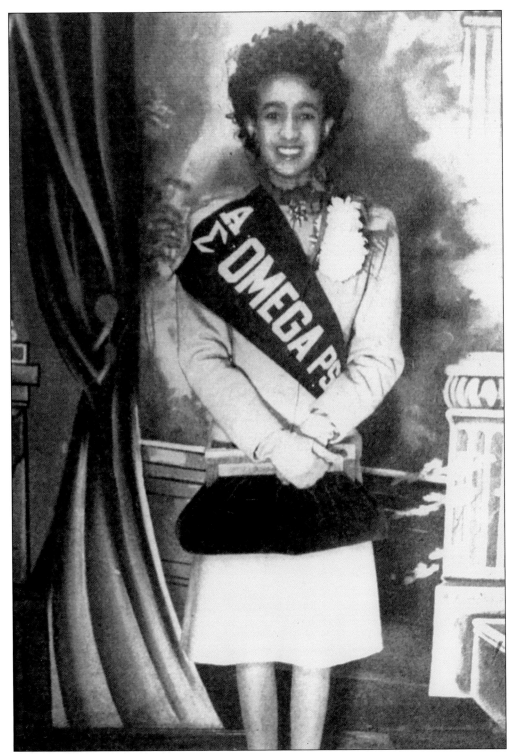
Ms. Gwendolyn Thomas served as the 1946 Homecoming Queen for the Alpha Sigma Chapter of the Omega Psi Phi Fraternity at Morris Brown College. (Courtesy of Skip Mason.)

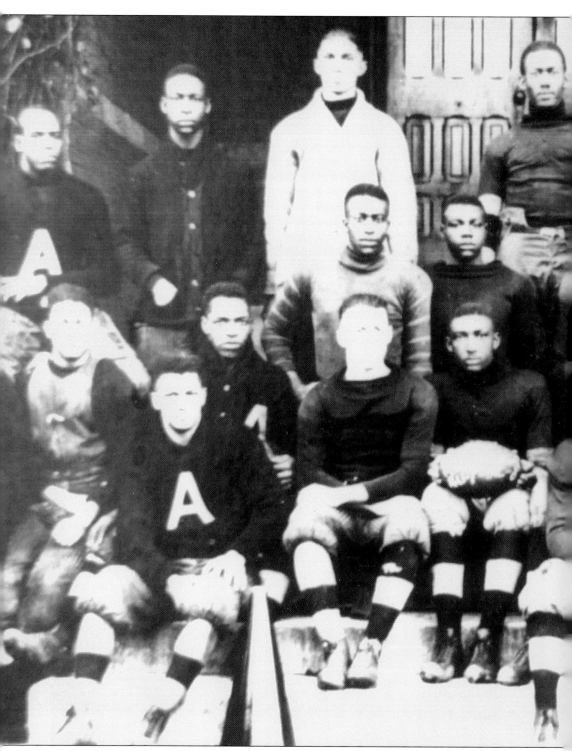

In 1899, John Hope introduced football to Atlanta University. Through his influence, the first football team was formed in 1900. The 1908, 1912, and 1916 teams made AU the "unquestioned

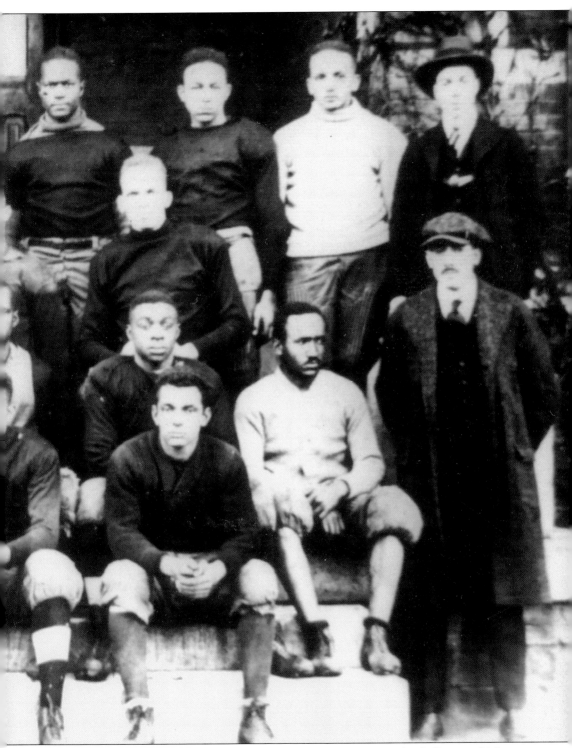
champions of Negro College football." Shown is the Crimson Hurricane football team of Atlanta University, *c.* 1920s.

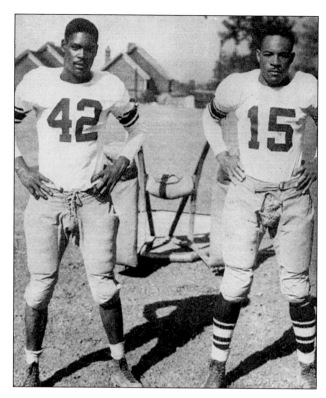

Pictured from left to right are the co-captains of the 1946 Morris Brown College football team, Richard Cooper and Clarence Fisher. Morris Brown organized its first football team in 1911 under the leadership of S.W. Nichols and D.H. Sims. (Courtesy of Skip Mason.)

The 1946 coaching staff of the Morris Brown Football Squad are pictured in this photograph. From left to right are A.P. Graves, H. "Bus" Thompson, and A.J. Lockhart. (Courtesy of Skip Mason.)

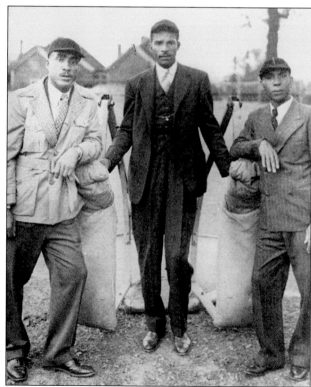

This c. 1958 photo shows the Atlanta Clark Booster Club presenting the college a check. From left to right are Fred McCoy, Richard Bolton, Robert Sellers, and John Carter.

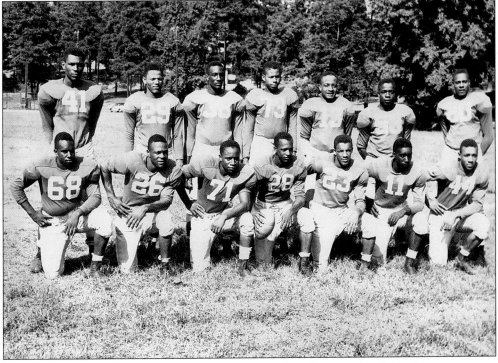

This photograph includes members of the c. 1950 Clark College Panther football team.

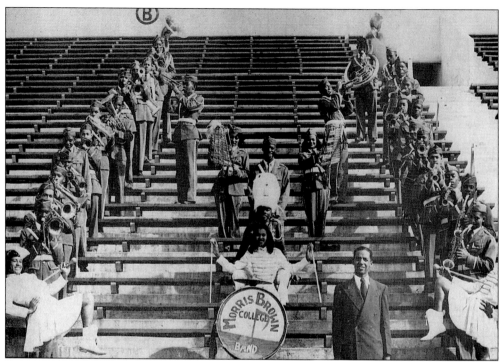

A *c.* 1948 photo shows the Morris Brown College Marching Band.

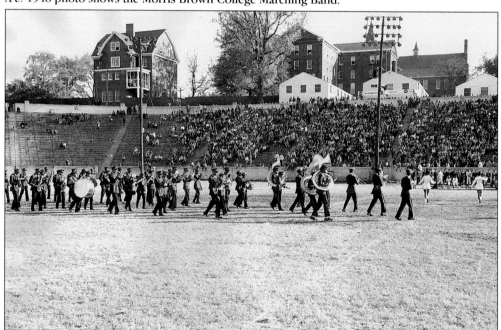

Constructed as the first permanent stadium in black college football, Herndon Stadium on the campus of Morris Brown provided an athletic venue for not only Morris Brown, but also Clark and Morehouse. In addition to football, Herndon Stadium was also the home of the Morris Brown baseball team. Pictured is a *c.* 1956 photo of the Clark College Marching Ramblers during a half-time performance.

During segregation, black colleges formed their own athletic conferences and associations. Pictured is the Coaches and Athletic Directors Conference, *c.* 1936. In the front row, seventh from left, is Coach B.T. Harvey of Morehouse. During his tenure at Morehouse from 1916 to 1951, B.T. Harvey gained recognition as a coach, athletic director, and professor of chemistry.

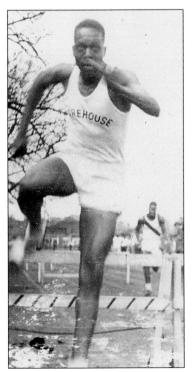
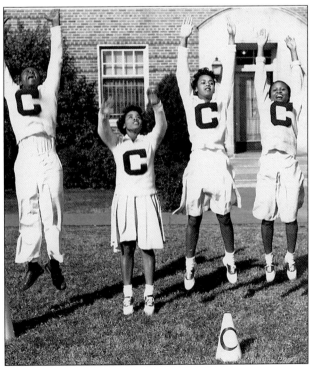

Left: A Morehouse track star navigates the hurdles on the AU athletic field, *c.* 1948. *Right*: The Clark College cheering squad is pictured *c.* 1951.

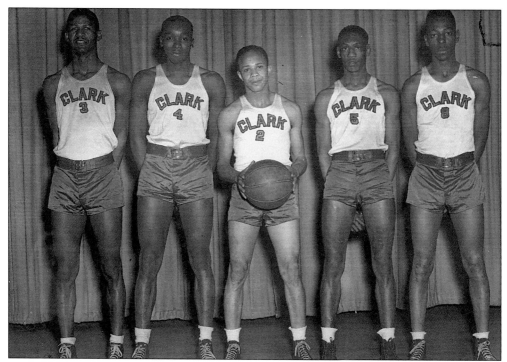

Pictured is a *c.* 1948 photo of the Clark College Basketeers. By 1954, under the leadership of Coach L.S. Epps, the Clark basketball team won its second SIAC championship by defeating Xavier, Florida A&M, and Fisk in the year-ending conference tournament.

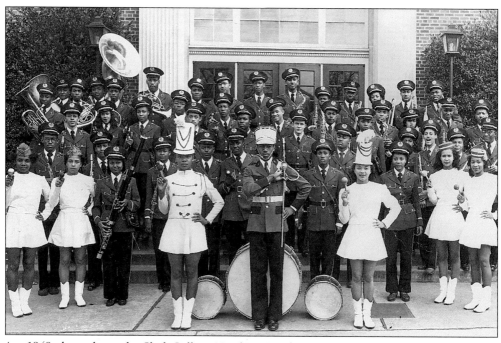

A *c.* 1949 photo shows the Clark College Marching Band.

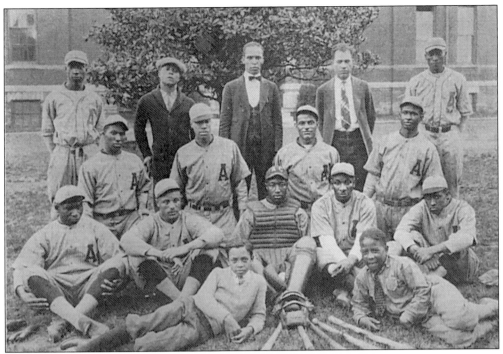

Baseball as a sport was initiated at Atlanta University in the early 1880s (Bacote, 1969). Early on, games were limited to the Atlanta schools, including Clark University and the Atlanta Baptist Seminary (Morehouse). According to Cade (1902), "Apparently Atlanta University's teams were fairly good since they won nearly all of the games played and always defeated Clark." This *c.* 1927 photo shows the AU baseball team. (Courtesy of Alexander D. Hamilton, VI.)

The *c.* 1927 coaches of the Atlanta University football team were, from left to right, Dr. Reeves, Coach Aiken, and Assistant Coach Harper. Prior to 1922, the coaches at AU were volunteers. In 1922, Walter "Chief" Aiken was employed as a coach. Between 1922 and 1924, Aiken's teams won 16 games, lost 2, and tied 4.

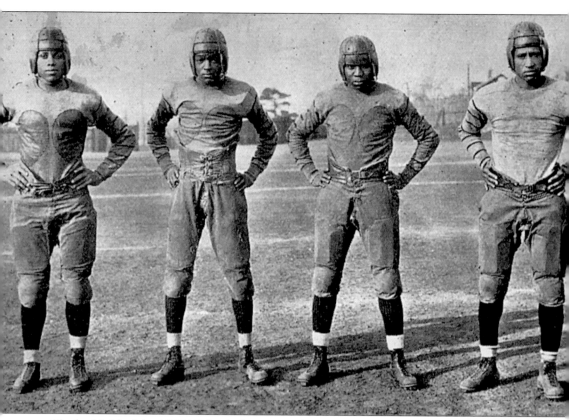
The backfield of the 1927 AU football team was known as the "Hurricane Ponies." (Courtesy of Alexander D. Hamilton, VI.)

Eight

ACADEMIC LIFE

Education has for its object the formation of character.
—Herbert Spencer

The DuBois Institute at Atlanta University was instrumental in the study of black America. In 1975, the institute sponsored a conference at AU celebrating the 75th anniversary of DuBois' germinal study, "The Philadelphia Negro." According to John Reid, the institute's director, the conference was designed to "underscore the shaping of the problems and issues of the time" (*AU Bulletin*, 1975). Dr. Allison Davis, John Dewey Professor at the University of Chicago, was the principal speaker for the conference.

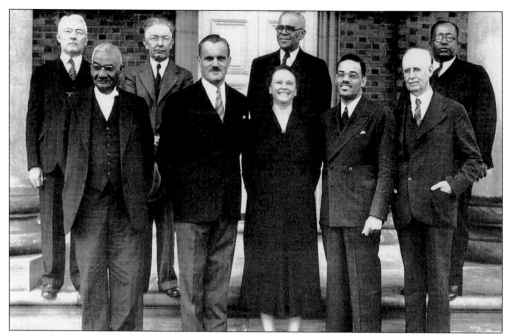

On November 18, 1938, Atlanta University established as a memorial to Dr. John Hope, its fifth president, in the first annual John Hope Lecture Series. Dr. Authur H. Compton of the University of Chicago served as the inaugural speaker. Dr. Compton was a noteworthy physicist, having won the Nobel Prize in 1927, and the Matteucci gold medal by the Italian Academy of Sciences in 1933. Shown from left to right are the following: (front row) Dr. E.R. Carter, pastor, Friendship Baptist Church; Dr. Arthur H. Compton; President Florence M. Reed of Spelman; President Rufus E. Clement of Atlanta University; and Dr. Otis Caldwell; (back row) Mr. Kendall Weisiger; President Spright Dowell of Mercer University; President John B. Watson of the Agriculture, Mechanical and Normal College of Arkansas; and Acting President Charles D. Hubert of Morehouse.

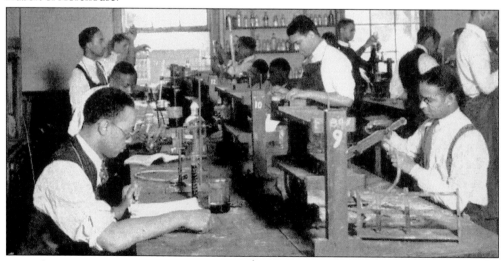

Erected in 1921, the Science Hall (later named John Hope Hall) of Morehouse was the first permanent building ever built at a black college for the exclusive purpose of teaching science. Pictured is a group of Morehouse students working in the laboratory, c. 1924.

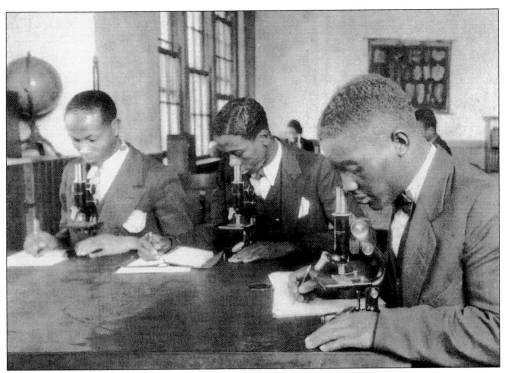

A group of Clark University men study in Leete Hall, c. 1927.

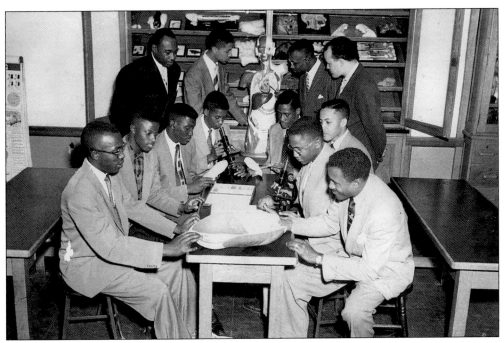

The Alpha Gamma Omega Biological Society of Clark College sponsored lectures, symposiums, and discussion sessions. Pictured is a c. 1954 photo of a group of society members discussing current issues in biology.

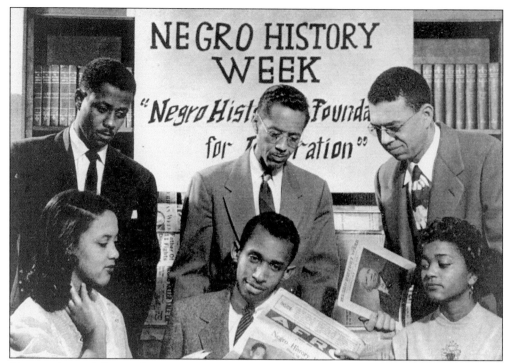

The members of the 1954 Negro History Week planning committee at Clark College are, from left to right, as follows: (standing) Rudolph Cohen, Prof. Edward Sweat, and Prof. James Green; (seated) Ada Clay, Aaron Favors, and Allie Howell. Sponsored by the Clark College Department of Social Sciences, the week's activities included public lectures, poetry, and debates.

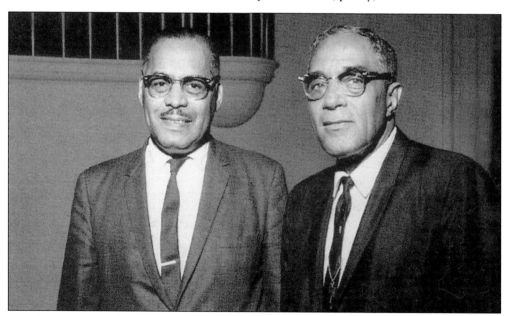

Dr. Clarence A. Bacote (left) and Dr. Charles H. Wesley, president of the ASNLH, consult with one another as they prepare for the semi-centennial meeting of the Association for the Study of Negro Life and History (ASNLH) held at Atlanta University in October of 1965.

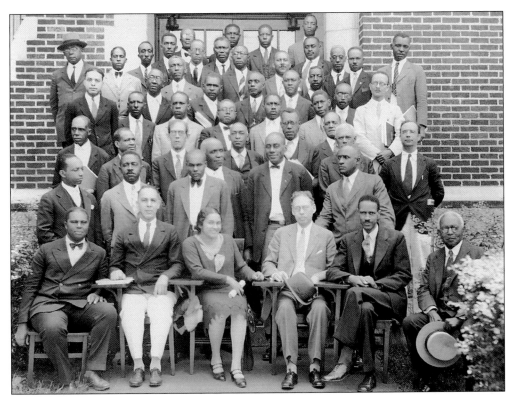

This 1930 photo shows the faculty and student body of the School of Pastors conference held at the Gammon Theological Seminary in South Atlanta.

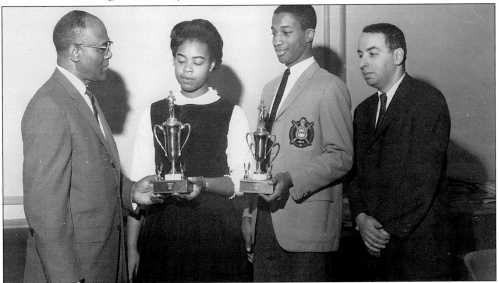

Dr. James P. Brawley, far left, presents winning awards to two Clark College debaters, c. 1962. The 1962–63 season for the Clark College debate team included tournaments at Brooklyn College, Johns Hopkins, NYU, and Hampton. In a field of 58 teams at NYU, the team placed fourth. Pictured is a third place award from the Emory University Peachtree Invitational Debate Tournament.

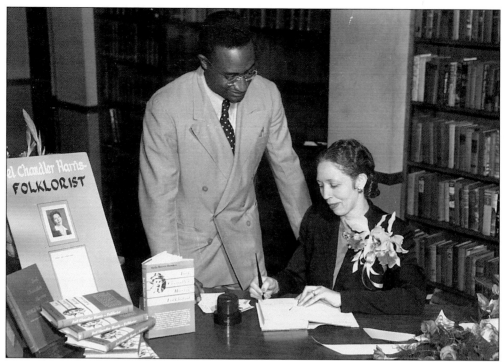

Dr. Stella Brewer Brookes autographs copies of her 1950 book, *Joel Chandler Harris, Folklorist*. She received national attention for her work, and *The Yale Review* listed it as one of the notable books of the year. Dr. Brookes served on the Clark faculty from 1924 to 1969, and was married on the "old" Clark campus to Professor E. Luther Brookes. He was a professor of chemistry for which the department is named, and was also a founder of Alpha Phi Alpha at Clark.

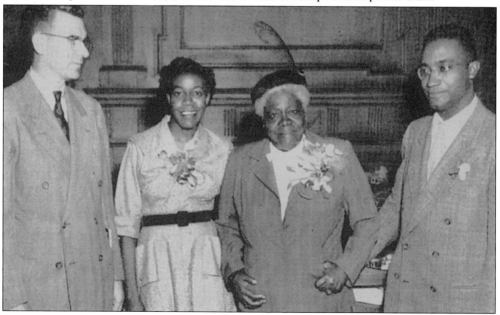

Making an appearance on the campus of Atlanta University are poet Gwendolyn Brooks, second from the left, and Mary McLeod Bethune, third from the left.

In April 1905, Dr. W.E.B. DuBois wrote Jacob Schiff of New York requesting financial support for the establishment of a first-class scholarly journal at Atlanta University. According to DuBois, he wanted to produce a quarterly that would "tell black people of the deeds of themselves and their neighbors, interpret the news of the world to them, and inspire them toward definite ideals." Beginning in 1940, the project would be realized with the inauguration of the *Phylon*, a quarterly "Review of Race and Culture." Publication of this new quarterly was, in many respects, a resuming of the old Atlanta University publications, which were issued annually for 18 years, between 1897 and 1914. Each issue of the *Phylon* included articles by outstanding scholars along with original verse and book reviews. This 1947 issue contains an article by Alain Locke, America's first black Rhodes Scholar.

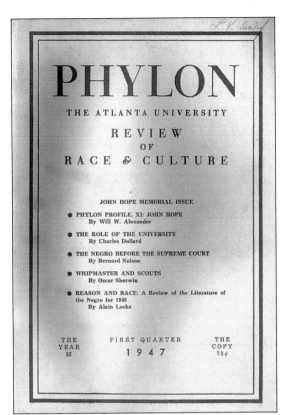

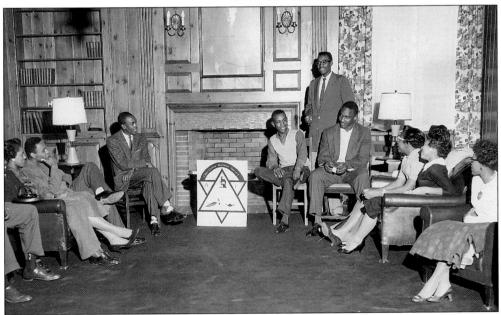

Organized in the early 1950s by Dr. Rie, Professor of Modern Languages at Clark College, the Pfeiffer Hall Friday Night Lecture Series provided an atmosphere for intellectual conversation and educational leisure. Pictured is a Pfeiffer Hall Series hosted by the Clark College Biological Society, c. 1953.

BIBLIOGRAPHY

Adams, M. *The History of Atlanta University, 1865–1929*. Atlanta: Atlanta University Press, 1930.
The Atlanta University Bulletin, July 1943, July 1969, January 1975.
Brawley, B. *History of Morehouse College*. College Park: McGrath Publishing Company, 1917.
Brawley, J.P. *The Clark College Legacy: An Interpretive History of Relevant Education 1869–1975*. Princeton: Princeton University Press, 1977.
Cade, J. "A Short History of Baseball at Atlanta University." *The Scroll*, VI. 1902.
Crump, W. and Wilson, C. *The Story of Kappa Alpha Psi: A History of the Beginning and Development of A College Greek Letter Organization 1911–1971*. Philadelphia: National Headquarters, 1972.
DuBois, W.E.B. *The Autobiography of W.E.B. DuBois*. CITY?: International Publishers, Inc., 1968.
DuBois, W.E.B. *The College Bred Negro*. Atlanta University Publications, No. 5. Atlanta: Atlanta University Press, 1900.
DuBois, W.E.B. *Darkwater*. New York: Harcourt, Brace and Howe, 1920.
DuBois, W.E.B. *The Souls of Black Folk*. Greenwich: Fawcett Publications, Inc., 1961.
Fuller, T. *Pictorial History of the American Negro*. Memphis: Pictorial History, Inc., 1933.
Klein, A. *Survey of Negro Colleges and Universities*. New York: Negro Universities Press, 1929.
Lincoln, C.E. *The Black Muslims in America*. Queens: Kayode Publications, 1961.
The Mentor, June 1939, March 1961.
Mason, H. *Black Atlanta in the Roaring Twenties*. Dover, New Hampshire: Arcadia Publishing, 1997.
Mays, B.E. *Born to Rebel: An Autobiography by Benjamin E. Mays*. New York: Scribners, 1971.
Miller, K. and Gay, J. *Progress and Achievements of the Colored People*. Washington, DC.: Manufacturing Publishers, 1917
Sewell, G. and Troup, C. *Morris Brown College: The First Hundred Years*. Atlanta: Morris Brown, 1981.
Thompson, D. *Private Black Colleges at the Crossroads*. Westport: Greenwood Press, 1973.
Torrence, R. *The Story of John Hope*. New York: The MacMillian Company, 1948.
Wesley, C. *The History of Alpha Phi Alpha: A Development in Negro College Life*. Washington: Foundation Publishers, 1948.